D0580244

capturing memories

YOUR FAMILY STORY IN PHOTOGRAPHS

capturing memories

YOUR FAMILY STORY IN PHOTOGRAPHS

MAUREEN A. TAYLOR

ancestry publishing

Library of Congress Cataloging-in-Publication Data

Taylor, Maureen Alice.
 Your family story in photographs : capturing memories / Maureen A. Taylor.
 p. cm.
 Includes bibliographical references.
 ISBN-13: 978-1-59331-303-6 (alk. paper) 1. Photography of families. 2. Photographs in genealogy. I. Title.
 TR681.F28T39 2007
 779'.2—dc22

 2007011958

Published by
Ancestry Publishing, a division of
The Generations Network, Inc.
360 West 4800 North
Provo, UT 84604

ISBN-13: 978-1-59331-303-6

First printing 2007

10 9 8 7 6 5 4 3 2 1

Printed in Canada.

To James and Sarah, the younger generation of family photographers

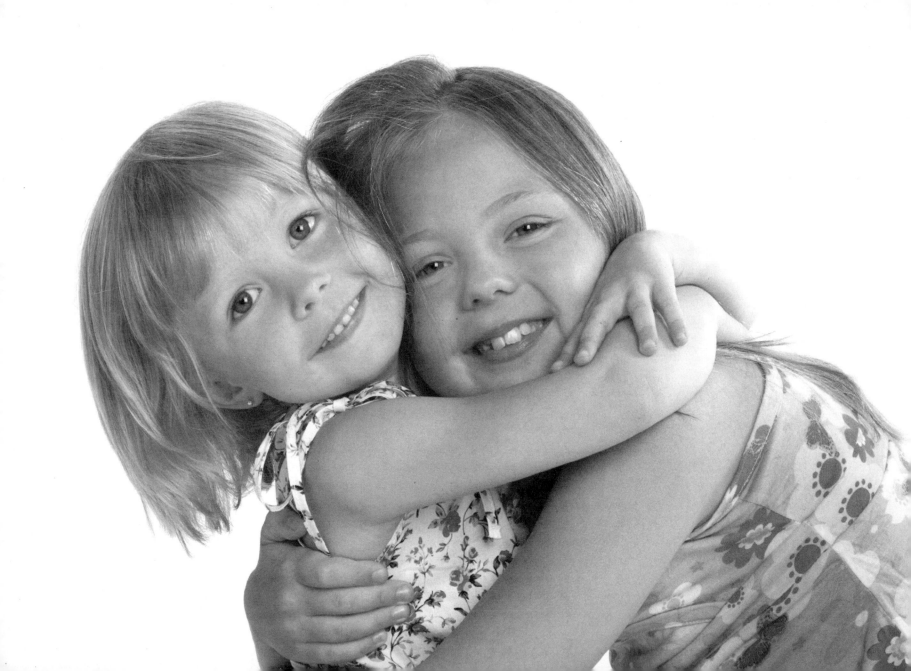

Contents

Introduction

ix

Acknowledgments

THERE ARE DIFFICULT MOMENTS IN the writing of every book. There is no question that consumer photography is evolving. Manufacturers are rolling out cutting-edge products at a pace too rapid for the average family photographer to understand and acquire. Writing this book meant finding a way to follow the trends without overwhelming the reader. Popular photography magazines, the Web, and photographically minded colleagues have kept me up to date with new technology and the changing photographic marketplace.

The list of people to thank for their advice and inspiration is a combination of family, friends, and colleagues. These individuals offered support and assistance when I needed it. When I was discouraged they gave encouragement, and when I was jubilant they were more than happy to celebrate along with me. I couldn't ask for a better group of people.

Several years ago, Lou Szucs, Jennifer Utley, Matt Wright, and Beau Sharborough of Ancestry Publishing suggested I work on this project. It's taken a lot longer than we all thought, but it's finally finished. Thank you for thinking of me.

I simply wouldn't be able to write without the staff at my public library. Not everything is online!

Margaret Reucroft and the rest of the reference staff retrieve articles and books I need to fact-check pieces. I know my interlibrary loan requests spike their user statistics. Thanks to the circulation staff for handling all those additional books.

Writers need focus groups, like any business. I have a circle of friends that act in that capacity. Jane Schwerdtfeger, Lynn Betlock, Sharyn Feeney, and Kathy Hinckley listen to me moan about writing challenges. Thank you for lending an ear.

I especially need to thank the staff at the Camera Company in Norwood, Massachusetts, for their patience in answering my questions and for showing off the latest products. Sometimes I really do buy new equipment.

Michele Leinaweaver and Jerry Jackson proofread the manuscript and suggested ways to improve it. Thank you for all your help.

And last, but not least, I need to thank my supportive family: James, who loves to try new gadgets; Sarah, for pushing my creative limits; and Dexter, for everything you do to make my writing possible.

—Maureen A. Taylor

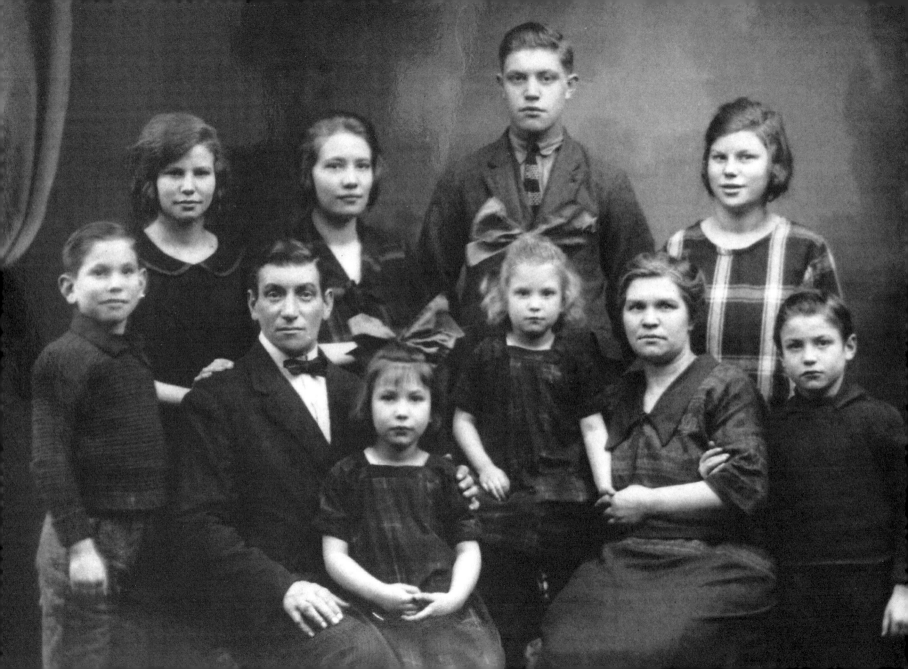

Introduction

IT'S EASY TO FORGET THAT FAMILY HISTORY is all around us. Research is about the past, but the materials used for genealogical inquiry—photographs, records, and artifacts—were all once part of someone's present. It's only because that person took time to sit for a photograph, write down the date of a birth or marriage in a family Bible, or save diaries and letters that you have a glimpse into your ancestor's world. Now it's your turn to capture the important moments of your lifetime. It can be done a photo at a time.

Photographing your heritage means documenting the people, places, and things that are important to you, most of which have genealogical significance. The accessibility of photographic options makes family history and picture taking a natural relationship. You don't have to be a professional photographer to accomplish that goal; it's as easy as pointing the camera and taking the picture. There are special techniques you'll want to acquire along the way to take the best possible photos, but there is plenty of help for even the most inexperienced novice.

Stop, Shoot, and Save

Cameras are available in a variety of formats and price ranges. Sharing photographs via e-mail is only a click away, and printing extra copies is possible using home

According to the Photo Marketing Association International, women take most family pictures.

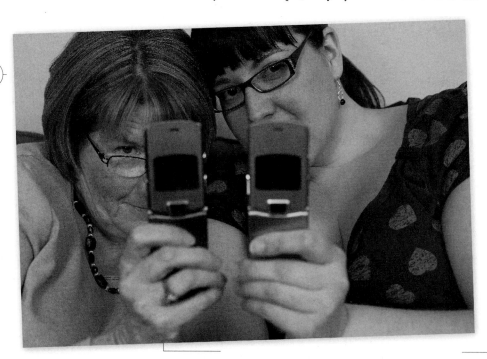

photo printers or kiosks in many stores. Photography is not just for professionals; there are inexpensive cameras, printing options, and sharing opportunities for even the newbie. There is no reason for anyone to shy away from using photographs to preserve family history moments for future generations. All it takes is a little time and patience. It's important to remember that family history is in the simple, everyday routines as well as in the special events. Heritage is about all your relatives, from the sometimes pesky ones that visit every holiday to the ones you can't find in the census. It also includes all the tangible evidence of their lives, such as the memorabilia your parents collected on their honeymoon. Photographs can preserve all those moments and materials.

Each year the marketing research department of the Photo Marketing Association International (PMA) <www.pmai.org> issues a report and forecast for the photographic industry. It highlights trends for consumers and professionals. It's clear that individuals are taking pictures like never before—digital, instant, and traditional film-based images as well as video. These photographs fill family albums, scrapbooks, and computer hard drives.

In the 2004 report, certain trends emerged that are still true several years later. It wasn't who is taking the photos that has changed but how we're sharing and using them.

Here are the industry highlights:

The typical family photographer is a woman.
Women of all ages use cameras to photograph their children and grandchildren. Of course, many of these

women are also genealogists who write down vital statistics in Bibles, create scrapbooks, and travel to find genealogical material.

Families with young children are a big piece of the market.

It's not surprising that families with young children are consumers of photographic products. Babies and small children do the cutest things, and mothers and fathers can't wait to preserve those precious moments in a photograph. We're taking a record number of pictures, with projections for 2006 as high as 30 billion.

Film sales are decreasing, while digital imaging is increasing.

Digital imaging is one of the fastest growing segments of the photo marketplace. In 2003, Lyra Research, an imaging research group, estimated that families in America would store more than 15 billion photos on home computers by the end of the year. If you don't currently own a digital camera, you'll probably buy one soon. The PMA 2004 forecast said that more than 40 percent of us would own a digital camera by the end of that year. Sales of digital cameras increased 13 percent from 2004 to 2005, with revenues decreasing due to lower sticker prices. Yet PMA suggests that by 2007, sales of these devices will slow due to market saturation. The largest area of growth in digital cameras during this period wasn't in the dedicated photo market but in camera phones. Digital imaging has several advantages for genealogists, but it's important to understand the medium before joining the digital revolution.

Sales of one-time-use, disposable cameras are stable.

Despite an overall decrease in sales of film cameras, single-use cameras still appeal to consumers. They appear on banquet tables at weddings, letting guests participate in photographing the event. Teenagers buy them because they are inexpensive, handy, and fun to use. There are a variety of disposable cameras, such as those for underwater use and ones that let you choose the format—snapshot or panorama.

Digital cameras offer consumers more options.

According to PMA marketing research for 2006, "consumers are realizing digital images can be used to personalize everyday items, create memorable gifts,

enhance Web pages and blogs, facilitate hobbies, and more." The rise in digital imaging does not mean that people are looking for ways to print their pictures. In fact, 35 percent of digital photographers made no prints, while another 34 percent printed them at home. While the first group didn't make standard prints, they shared images with relatives electronically and made greeting cards, calendars, and T-shirts. Photo books created on photo-processing websites is considered the next area of growth.

Do you recognize yourself in any of these trends? Personally, I'd like to see a report titled "Genealogists dominate the consumer photographic market." Of course, none of the industry reports suggest that genealogy is one of the factors for picture-taking habits, but I think it is behind every family photograph because each of us is trying to save a bit of our history in pictures. The average camera owner probably doesn't think about taking pictures in those terms, but that's what it is. Photographers are often the visual genealogists in their families. They snap away at weddings, birthday parties, school events, and sometimes even funerals, trying to freeze the present in an image.

Camera-Carrying Habits

Do you carry a camera with you at all times, or do you usually leave it at home? Here's a way to remember to bring it with you: Think about the last time you were at a family event and forgot to bring your camera. Unless you or someone else in the family preserved the day in a visual or oral medium, it's lost forever, except in memory. Artists in the family can draw or paint representations of the event, but for most of us, sharing reminiscences of that occasion will have to suffice. Now remember how often you would have liked to have had a picture of someone at that occasion. This thought should be enough to have you toting a camera wherever you go—regardless of whether it's a disposable unit, a camera built into your cell phone or PDA, or a professional-model film camera.

If it's so easy to carry a camera for those "just in case" moments, then why don't most of us do it? Well, here are some of common reasons I've heard.

It's too heavy.

This argument might have worked in the past when cameras were heavier and you carried lenses with you. Many cameras are now feather light, and the versatility

of built-in, variable-length lenses means you don't have to lug extra equipment with you. I've seen a number of cameras that are small enough to carry in a pocket that don't compromise image quality. Even digital video cameras are compact and lightweight, so there is no support for this excuse.

Travel might cause damage.

Yes, it's true you can damage your camera when you travel, but it can also happen at home. You bought the camera to take pictures, so don't leave it home just in case of accidents or theft. There is a simple solution: Leave the expensive model at home and pack a few disposables or an inexpensive model.

I forgot to buy batteries and extra film.

This is a family favorite. In the rush of planning and packing, someone always forgets to buy film and batteries. Let's move this to the top of your list of items to remember and eliminate this excuse. Unless you're traveling outside the country, chances are you'll be able to find film and batteries wherever you go. If you purchase film in a foreign country, verify that the development process is the same as at home, or have

the roll processed before you come home. The processing method usually appears on the box. Digital camera users should pack an extra charged battery pack or use a camera that uses regular batteries (bring extras). Purchasing an additional memory card for trips is also a must.

An Everyday Opportunity

Opportunities to capture family history occur every day. You never know when the next special moment will happen. It might be a child's first steps, a chance to photograph a family artifact, or a sudden genealogical discovery in a town cemetery. Regardless of the impetus for a photograph, you'll be glad you have a way to capture it.

Taking pictures is simple. In the past, it meant buying a film camera, loading it, clicking the shutter, processing the snapshots, and putting them in an album. The camera you bought was fairly uncomplicated, unless you bought a professional model. Now, while it's still easy to snap a few pictures, the sheer variety of photographic options can be overwhelming. Today cameras are everywhere—in watches, handheld devices, and cell phones, to name a few places—so there's no good excuse for not

Don't wait for a special occasion to take pictures of your family. Make it part of your everyday life.

having a camera handy. Moving images—film, video, and digital video—are another way to capture family history. Still digital cameras that create short segments are not unusual, and digital video is replacing tape video equipment. Prices for consumer-based moving image cameras are decreasing, placing them within the reach of the average family photographer. Effectively using these devices requires knowledge of what makes a good "film"—from shooting the scene to editing the result. This can all be done with your home computer, some editing software, and a creative eye.

Join the fun of photographing your heritage—people, houses, artifacts, and more. Genealogy is about paper-based documents, but in our visual society, it is increasingly about photographs. Create a visual archive of family history to provide descendants with pictures of all the current members of your family tree. Use the photographs and moving images you've accumulated to enliven your family story. Just remember to label all your pictures so that your descendants know why they need to keep all your boxes of photographs.

This book offers guidance for the genealogist who wants to photographically preserve his or her

family history. It contains tips on purchasing equipment, gives suggestions for composing compelling images, and offers solutions for planning an image archive one shot at a time. Advice on photographing gravestones and artifacts will help you get good-quality images on research trips. Follow the tips on sharing photos, or work on shooting a family documentary to get the whole family involved.

Documenting your family is a wonderful way to preserve living history. Appoint yourself as the "official family photographer" or invite others to help. Photography and genealogy, when combined, become a hobby that gets the whole clan involved. In my own family there are many photographers, from kids to elderly relatives, with abilities that range from amateur to expert. Everyone shares their pictures so that with all this picture taking happening, each family is bound to find a few good shots to go in the family albums. Try it with your family.

⊕ A Camera for Everyone

PURCHASING A CAMERA—FILM OR DIGITAL—is an investment. This is equipment you'll likely use for years, so you want to make an appropriate choice. Here's a piece of advice: The *right* camera is the one that fits your particular budget and photo needs. It's different for everyone. Instead of trying to find the latest model heralded by reviewers, spend time creating a wish list of camera features, examining your budget, and doing research to determine the appropriate models and formats that fit your level of expertise.

The choices are almost endless. Thus, a single visit to a camera shop can overwhelm a first-time camera buyer. It's important to have a plan. Prepare beforehand by educating yourself about camera features. Develop a set of criteria broken down into what's important versus what's nice to have. Budget constraints will ultimately decide some of these issues, as will your comfort level with the individual cameras. Turn your camera-buying expedition into a fun activity rather than one that intimidates.

Needs and Wants

One of the first questions camera store personnel are going to ask you is, "What are you going to use the

camera for?" Your answer helps them direct you to suitable models. Explaining that you just want to take good photographs is not enough. The salesperson wants to sell you a camera that matches your picture-taking desires. Making a list of all of the possible ways you envision using the camera can help you determine which features are most important. Start by outlining all the possible scenarios for usage. Here are a few suggestions:

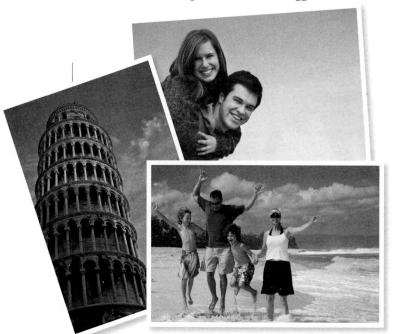

People

If you only intend to take pictures of people, then almost any camera will work. Even disposable cameras can produce a pretty good portrait, if you know how to use them and are aware of their limitations. Action shots require a faster shutter speed, so if you intend to stop movement—showing kids frozen mid-jump, for instance—mention that to the salesperson.

Places

Once again, most cameras can handle simple vacation photographs. However, if you decide to take close-up shots of nature (or the details in a family artifact) you'll want a camera with some flexibility. Professional landscape photographers use wide-angle lenses for special effects.

Objects

Choosing equipment for photographing artifacts under variable conditions can be tricky. Taking a picture of a piece of furniture is different from focusing on a close-up of the monogram on a piece of silver.

Copying Photographs and Manuscripts

Making copy prints of photographs and manuscripts in family collections without scanning them requires a camera with close-up capabilities. A simple point-and-shoot camera won't work. Take a small object or photograph with you to try cameras so that you can experiment with them before making your final purchase. A basic 50 mm lens with supplementary close-up lenses will work, but some of the newer digital cameras have everything built in.

Skill Level

How much experience do you have with photography? A first-time camera buyer needs time to acquire a certain comfort level with cameras in general before moving on to a multifunction model. A point-and-shoot camera that only requires users to push the shutter may be the best model for you, but if you're enamored of technical devices, you'll want a camera with lots of features.

In any case, the worst time to buy a camera is right before you need it. Being in a rush can lead to buyer's remorse. Don't purchase a camera before a special event unless you have time to play with it to "get the bugs out" of your technique and to read the manual. Reading the manual is like reading the directions before taking a test. If you don't do it, you might miss an important detail. Take your time. If technical jargon scares you, then don't purchase a camera that requires special knowledge unless you are prepared to study the manual or take a class. Decide to buy after you've tried the camera in the store to make sure you're comfortable using it.

Budget

When I walk into a camera store or search for a camera online, I have an amount of money I want to spend in mind. If I'm talking with store personnel, I start with the following statement: "I'm on a budget, and this is what I've set aside for the total purchase, including accessories." There really is a camera for everyone and every budget, but you need to set some limits before you start shopping. It helps to define the options.

The Photo Marketing Association International found that households with below-average incomes, those headed by individuals under twenty-five, or those with teenagers were more apt to use disposable, one-time-use cameras. Disposable cameras are inexpensive devices that come in a variety of formats. For instance, the underwater model is very popular with my children

3

on vacation. Investing in an underwater film camera doesn't make sense for a once-a-year occasion. Unlike digital cameras, one-time-use cameras come with the added cost of film developing. In most cases it is cheaper to buy the camera than it is to develop and print the photographs. When you determine a budget for a camera purchase, do you consider the cost of film and processing or, in the case of digital imaging, the peripherals? Here are a few things to keep in mind:

- Film cameras have costs that continue for as long as you use them. Film, batteries, and processing costs will be incurred each time you take a picture.

- Instant photographs are among the most expensive to produce. These cameras are relatively inexpensive, and the "fun" factor was a good selling point before digital cameras were available, but the per-picture cost is high. If you can afford the camera but not the film, you won't be using the camera very often.

- Digital imaging offers instant viewing, instant editing, and the opportunity to retake bad photos. It also has the "free" film enticement. You never have to buy film again, but the up-front costs can be significant, with battery packs, special printers, or

the cost of ordering prints. While you don't have to own a computer to use a digital camera, you may want to own one to upload digital images to edit them. Consider the cost of the peripherals with your need for immediate results.

Developing a Budget

Purchasing a camera is just the beginning. The cost of the accessories and extras you'll need can equal what you spend on the camera itself. It helps to make a shopping list of items because it is a challenge to balance the cost of the camera with the extras while sticking to a budget. Purchase the camera first and slowly build your equipment hoard a piece at a time as projects arise and with money saved. To help you know which accessories you might need, here are shopping lists for both digital and film cameras.

Digital Camera

- Extra battery

- Memory card

- Computer hard drive space (you need a lot of it to store digital images)

- Photo printer
- External storage device for backups

Film Camera

- Extra lenses
- Flash (many cameras have built-in flash units)
- Filters

Accessories for Both

- Carrying case
- Tripod
- Shutter release
- Lens-cleaning supplies

Set a budget for the camera, figure in the other costs (film, peripherals, prints, and processing), and move on to the next step—research. It may take several trips to the store before you settle on a realistic budget for this investment.

Do Your Research

I'll admit to being a little compulsive when it comes to major purchases. I like to gather information from a variety of sources before making a decision. I'll consult magazines and online sites, talk with store personnel, and consult friends and family. It's all about becoming an informed consumer. Here's why.

The type of photographic equipment you'll buy depends on the type of photographs you'll take and your budget.

5

Magazines

Most photography magazines publish a guide to new products, including cameras. Writers compare cameras to each other and to last year's models as well. These individuals have already taken the cameras out in the field and tested them. They may not use cameras in exactly the same way that you will, but generally the reviewers have experience with cameras and can highlight both the positive and negative aspects of each.

Most magazines like *PC Photo* <www.pcphotomag.com> and *Popular Photography & Imaging* <www.popphoto.com> now cover all types of cameras, so you'll see an overview of the whole industry. *Consumer Reports*, a general, consumer product review website and magazine, also tests cameras <www.consumerreports.org>.

Online Sources of Information

As everyone knows, there is a lot of information online, but finding the data and trusting it are two different things. Find material in the following ways:

- **E-zines** offer comparison reviews, like print magazines, and cover a wide range of photo-related topics, including how to purchase a camera. Look for them using "photography e-zines" in a search engine.

- Familiarize yourself with photography magazines by visiting the periodical section of a library or a bookstore. Then take a look at the **Web equivalent**. Websites for print magazines specializing in photography can be found by searching for their titles with a search engine. Sites generally contain material from current issues as well as Web-exclusive articles. Search for photography magazines using a site like Google <www.google.com>.

- **Shopping sites** and even some photo store sites give consumers a chance to see how cameras compare to each other based on photo quality, ease of use, and special features. These lists are usually arranged by price. In addition, these sites often include reviews from people who have purchased the equipment.

- **Newsgroups** allow you to post questions. Search for appropriate groups by using groups at Google <www.google.com> or Yahoo! Messenger <www.yahoo.com>. Look at the offerings available via your favorite search engine.

- **Message boards** on websites can connect you with others who can respond to your questions. Genforum <www.genforum.com> has a category

for photo-related queries for genealogists, but to find more general forums, search for "photography message boards."

- **Search the Web** by topic, such as "purchasing a camera," or by specific make and model. Searching by topic results in general articles that will help you decide how to buy, while searching by make and model provides you with price comparisons and reviews.

- **Manufacturers' websites** are a great way to learn about new products, read press releases, or learn new ways to use cameras or other equipment.

- If your friends aren't vocal about the positive and negatives aspects of their cameras, look at a site like **Epinions.com** <www.epinions.com>. You'll find easy-to-read ratings submitted by individuals along with short statements about the equipment.

Used vs. New

Not everyone buys a new car, and the same is true with cameras. There is an active market for used equipment. Don't immediately dismiss buying a used camera. They can be less expensive than new ones and might work

just as well, depending on how much use or abuse they have experienced. Photo organizations usually know where to buy used equipment in good condition. For instance, twice each year the Photographic Historical Society of New England <www.phsne.org> sponsors

an event where vendors and collectors gather to buy older model cameras and photo gadgets. I've found used equipment in photo stores and on the Web. Make sure everything works before you purchase and that the item comes with a written warranty. As long as the secondhand equipment comes with the features you desire and uses film, batteries, or memory cards that are still available, do some price comparisons. You might discover that buying used is a better deal than investing in a new model.

Evaluating Cameras

Evaluate cameras according to several factors, such as durability, ease of use, size, and weight. Durability covers the conditions under which you can use your camera based on construction of the main body and if it is manufactured for special conditions, like operating underwater. Ease of use is a personal preference based on how the camera feels when you hold it, the accessibility of the controls, and, in digital cameras, the usefulness of the menu. Cameras shouldn't be so complicated that you have to refer to the manual before taking every shot. Anyone with some familiarity with photography is tempted to pick up a camera

and use it, but it's a good idea to browse through the manual first to familiarize yourself with its features. Reviewers focus on these factors when they try out new products, and you should as well. A camera that is heavy, cumbersome, and difficult to use is going to be left home.

One of the key factors in purchasing a camera is the optical quality of the lens(es). If you have to choose between a camera with lots of features or one with a great lens, go for the lens. The quality of the optical glass is one of the items rated by reviewers. Certain manufacturers have better reputations for producing cameras with high-quality lenses. Don't confuse optical quality with lens format. Format refers to the type of photograph you can take with the lens, not the sharpness of the image. Lenses come in a variety of formats, including variable-length, adjustable lenses.

- Standard camera lenses are 50 mm. These lightweight, small lenses see the world the way you do with natural sight.

- While the 50 mm is a good basic lens, the 28–80 mm zoom lens gives you the flexibility of three lenses—standard, wide-angle, and telephoto—in one.

- Macro lenses are for close-up photography because they allow you to focus close to the subject. You can purchase a set of close-up lenses for a 50 mm lens that enables you to take close-up shots. Alternately, you could purchase separate macro lenses.

- Wide-angle lenses lower than 50 mm are good for photographing landscapes or for shots where you want to focus on the foreground rather than the background. Typical wide-angle lenses are 28 mm.

- A telephoto lens brings faraway objects into sharp focus, which is great if you're trying to capture the action at a sporting event. You see a small piece of a scene at one time rather than the whole panorama. A good way to think about a telephoto lens is to compare it to vision using a telescope. Common telephoto lenses are 80 mm.

- Fish-eye lenses are wide angle lenses that are often used to take pictures of landscapes because they allow the camera to capture a full 180-degree view. Fish-eye photographs are distorted with curves at the edges.

Reading the Specifications: Terminology

There is one more thing you need to understand before making a final choice, and that is the vocabulary of photography. When you research a camera, you'll see specifications for each particular model. Camera specs can seem like another language. Regardless of the type

of camera you are considering, you need to understand certain terms to know what you're buying. The more expensive the camera, the more items will appear in the specifications. Become familiar with the basics, and ask for an explanation when store personnel use unfamiliar terminology or you see an unknown term in camera specifications. A good guide is *The Photography Encyclopedia* by Fred W., Gloria S., and Timothy W. McDarrah (Schirmer Books, 1999). If that isn't handy, try a dictionary. Following is a short list of common terms. Terminology sections appear in other chapters as well and are specific to the topic being discussed.

Camera type: Refers to single-lens reflex (SLR) cameras, instant, single-use, point-and-shoot, or digital.

Camera format: Identifies the film format used in the model being profiled, such as 35 mm, APS (auto programming system), or digital.

Maximum shutter speed/minimum shutter speed: Details the speed of the shutter opening and closing during a shot. This is important for freezing the motion in an action shot.

Maximum aperture/minimum aperture: The aperture controls the amount of light let into the camera.

Also known as f-stop, it is represented by numerical values. The higher the number, the smaller the opening and the less light.

LCD display: This is a feature only on digital cameras. LCD stands for liquid crystal display and refers to the monitor through which you view the scene.

Self-timer delay: States how much time elapses before a shot is taken in self-timer mode.

Camera features: Autofocus allows you to select your focus point and then recompose the image in the frame without losing the original focus point. Autoexposure lets the camera evaluate the scene and adjust the settings.

Lens coverage: Describes the size of lens that comes with the camera.

Autofocus: Tells you whether the camera automatically focuses instead of being manually controlled.

Focal length: References the lens specifications, e.g., 28 mm. Usually described as minimum and maximum.

Minimum focus range: Describes the smallest distance at which you can maintain focus.

Included accessories: Describes what comes standard with the unit and usually refers to a strap, body cap, and lens cap. A few cameras have cases as part of the purchase package.

Camera flash: Tells you if the camera comes with a built-in flash unit and, if so, what type it is.

Flash features: Identifies the type of flash available with the camera. An AF illuminator fires a single, short burst of light that allows the camera's autofocus system to focus in total darkness. Red-eye reduction fires a series of short flashes to eliminate those red dots in your subjects' eyes.

Flash modes: No longer are flash photographs limited to a single burst of light. Many cameras now offer different types of flash lighting, such as fill-in mode (to reduce shadows), auto mode (will go off when you press the shutter or when the camera senses a flash is needed), flash off mode (means it won't fire at all), and red-eye reduction (a pulsating light that eliminates red dots in eyes).

Battery features: Details what kind of battery is required, the type you'll need, and how many you'll need.

Weight: Provides data on the camera's weight in pounds.

Also known as: Other names the same camera is sold under.

11

Technical support URL: Supplies you with a website where you can go for answers to frequently asked questions and support.

These are just some of the terms you'll encounter when you start to research your camera options. If you find a word you can't decipher, try entering the term into an online search engine to locate an explanation.

The Last Decision: Warranties

Probably the last question store employees will ask you when you purchase camera equipment is whether you want to add on an extended service plan (ESP). An ESP extends the original warranty of your purchase. Camera price determines the cost of an extended warranty.

In my experience, technologically advanced machinery often needs more repairs, and they're costly. So is the added expense of an ESP really worth it? Here are a couple of items to consider.

- What did the equipment cost? Warranty prices are a fraction of the original purchase price and can be a good value if you invested in expensive equipment. Repairs to digital cameras often cost more, so ESPs for such cameras are usually worth it.

- Who is selling the warranty? In other words, is the store offering the warranty still going to be in business when you need to use it? Stick with a manufacturer's ESP or one from a reputable outlet with a history of good service, like Mack Camera <www.mackcamera.com>. You don't always have a choice, but it helps to ask store personnel.

- How long does it last? If you purchase a long-term warranty, it's helpful to verify that it's transferable if you sell the camera. If you select a short-term one, you'll want to know if the warranty is renewable at the end. Most ESPs last from one to seven years.

- What does it cover? Here's where you want to read the fine print. Not all warranties are the same. Ritz Camera <www.ritzcamera.com> offers an ESP that covers most types of damage or mechanical problems (except fire and theft) and will replace the camera if it can't be repaired. However, not all ESPs cover damage due to accidents like dropping the camera.

- How do you use the warranty? Keep the registration information and your receipt for the equipment purchase together in a safe place. You will need both

to be able to use the warranty. It also helps to write down the serial number of the product on the receipt. If you need to have your equipment repaired, contact the company and follow its instructions. You'll need to pay for shipping, but if you have adequate coverage, there shouldn't be any other charges.

At this point you've followed my advice, researched the product, set a budget, and made a purchase. Now it's time to have fun with your camera photographing all those people, places, and objects that remind you of family and genealogy.

Family Photo Basics: Processing and Printing

IN THE OLD DAYS, YOU TOOK pictures, dropped them off at the lab, and waited a week for prints and negatives to come back. No more. Photographers now have a wide selection of processing choices, so many that it can be confusing. Make informed decisions by educating yourself about the options. You might save money and learn some new ways to share your photographs.

Film and Formats

While most camera film formats now fall into standard categories, historically there has been a wide variety of film on the market suited for specific camera models.

Film cameras, other than large-format professional models, take one of two sizes of film: 35 mm or 24 mm. The 24 mm film works only with APS models. You can't swap film between the two types of cameras. You can, however, use any 35 mm film in a camera intended for that size. The same is true for APS 24 mm film. The film manufacturer offers standard sizes, so you can purchase any film as long as it is the correct size for your camera. There are differences in film manufactured in foreign countries, so if you're trying to buy film while on vacation, stick with a known company so that the film can be processed when you return. Read the side

of the box to verify the type of processing needed. Stick to film that requires either C-41 color print processing or E-6 for slides.

Film for consumer cameras falls into two main categories: slides or prints. Within each category there are options, such as black and white or color and daylight or tungsten. Tungsten film is generally used when tung-

sten lights are used in copy stands. Films manufactured by different companies have subtle color differences. Consumer photography magazines feature comparisons that highlight those variations.

On the side of each box of film, you'll find a number and three letters—ASA or ISO. This refers to the light receptivity of the film. ASA 400 film is twice as receptive, or fast, as ASA 200. In low-light situations, you might want to use ASA 800, while in bright daylight, ASA 200 would be sufficient. Cameras either automatically read the ASA of the film, or you have to set the correct ASA manually. If you have a camera that requires you to manually set the ASA and you forget to do it, ask the photo processor if the film can still be developed. The processor will need to know the ASA setting you used.

There are at least three ways to have your film developed. You can drop it off at a quick-develop place (which might be a photo shop or your local pharmacy), you can leave it at a professional camera store that offers processing, or you can send it to an online processor. There are subtle differences.

- Camera stores staffed by professionals can offer advice when your photographs come out wrong. If you

ask what you did wrong on a photo or two, they can tell you. That's an added benefit of using an in-house lab.

- One-hour labs are convenient. You'll be able to see your photographs without waiting days.

- Online film processors like Snapfish.com develop your film, send you the prints, and can post a digital version online. It takes longer than using a local lab but usually costs less.

After you decide who's going to process your film, you'll be asked to choose developing options. While digital imaging is rapidly replacing film as the photographic medium of choice, there are still plenty of ways to obtain good-quality prints of your family photos.

- Double prints are a great idea, especially if you think you're going to use the prints in artistic projects like scrapbooks. Save an original for the archive, and crop the duplicate.

- Ordering your photographs on a CD-ROM saves you the trouble of scanning them later on. Rather than request this instead of prints, get the CD in addition to the prints. The prints will be produced

Film Tips

- Use film before the expiration date on the side of the box. Film has a shelf life that can affect the final product.

- Store color film in a refrigerator, as heat will affect picture quality. Just put it in your refrigerator next to the milk. Your friends will think you're odd, but your pictures will be the right colors.

- Don't keep film in the camera for a long time. You'll forget what's on the roll, and the quality may be affected by the first two items on this list.

- Light will ruin your film. Don't open the camera back before rewinding the film inside the canister.

- After loading film into your camera, check to make sure it advances, signaling it's loaded properly. Imagine spending all day shooting a family event only to realize that your camera wasn't taking pictures at all because the film was still in the canister.

- Ask about the effects of airport screening on your film. Whenever possible, try to place film in your carry-on bag.

17

using "real" photo paper that you may not be able to use at home.

- Kodak Perfect Touch reduces red-eye, lightens dark shadows, and prints more colorful photographs.

- If you use an online photo processor, you may be able to post your photographs on a website, making it a lot easier to share them with family. Find out if there is a cost associated with photo sharing, if users

need a password to access your photographs, and how long they will be posted online.

Editing

One of the best parts of digital imaging is being able to improve your photographs without retaking the shot. You can eliminate red-eye or extra trees and even add people into digital images. Before purchasing a photo-editing program, see what came with your printer and

Developing Old Negatives

If you have old, undeveloped film lying around the house, don't throw it out. It still might be possible to develop the film, depending on its age and the storage conditions. Companies like Rocky Mountain Film Labo-ratory ‹www.rockymountainfilm.com› can develop most film, including disc and movie film.

Need an Extra Copy?

Try one of these suggestions for making copies of prints or from negatives:

- Order extra prints at the time of processing.

- Take the negative to a photo processor to order extra copies. Use care when writing the negative

number down. It's the number directly underneath the frame, even if it is 26A rather than 26.

- Order a CD of the digital images, and either print them yourself at home or upload them to an online processing site to order copies.

- Scan the photograph or the negative to produce copies at home or upload to an online processor.

- Use a self-operated kiosk machine at a local store.

camera. You might not need to make an extra purchase. Examine program requirements to verify that the software will work on your computer, and see where the software capabilities overlap. Don't expect to be able to make sophisticated changes instantly; it takes time to learn the finer points of photo editing. If you're overwhelmed by technology, start with a simple program such as Microsoft's *Picture It!* rather than the latest version of Adobe *PhotoShop*. Any store that sells software usually carries a variety of photo-editing software. The same online sites that rate cameras also publish articles on software products for photographers. See chapter 4, "Taking Better Pictures," for additional resources.

Printing

Here's a digital dilemma—to print or not to print? Some people argue that you don't have to print your digital images because they can be viewed on a screen, posted on the Web, or shared. There are even digital picture frames for a variety of shots. But I disagree. Having traditional photo prints made of your digital files makes sense for family historians. Sure, you can swap CD-ROMs, but will your relatives in the next generation be able to look at those digital images when

you consider technological change? For me, looking at a photographic print is an aesthetic experience.

So, if you choose to print your photographs, how do you do it—with your home printer, using an online photo service, or using a self-service kiosk? It doesn't matter which method you select, as long as the company uses materials and processing that will last. Good quality photo processing is easier to find than you might think.

While close to 100 percent of film users are satisfied with the prints they receive, that number drops dramatically for people printing digital images at home. Many manufacturers want to satisfy those digital users by making it easier for consumers to obtain copies of digital images at affordable prices through retail outlets. What many digital camera users don't realize is that prints made at home using regular inks and papers have a very short shelf life, maybe less than two years. However, it is possible to make prints at home using high-quality inks and papers that may outlive your grandmother's black-and-white photographs.

Henry Wilhelm and Carol Brower are the authors of *The Permanence and Care of Color Photographs: Traditional and Digital Color Prints, Color Negatives, Slides*

Using high-quality inks and papers with many of today's printers creates prints that last for generations.

and Motion Pictures (Preservation Publishing Co, 1993). Wilhelm tests new printers, inks, and papers to see if they meet certain preservation standards. On Wilhelm's website <www.wilhelm-research.com> you can read reviews of various printing mediums, including his latest research.

Printing digital images at home has gotten easier and more permanent as manufacturers have concerned themselves with long-term preservation issues. For example, Epson printers use DuraBrite inks, HP uses Vivera inks, and Canon uses Pixma inks. Photos printed with those inks on Crane's Museo papers, HP Premium Plus Paper, or Epson photo papers last more than one hundred years on display according to rapid aging tests conducted by companies such as Wilhelm Imaging Research (<www.wilhelm-research.com>). Prints stored in the dark or in acid- and lignin-free albums last as long as two hundred years. Select a cheap ink and good paper or vice versa, and the images won't last. However, there is more good news to come in the future.

If you decide to use a self-service kiosk or an online processing site, look for those that use products that meet Wilhelm's preservation standards. You can even use these services to make copies of your other prints.

Buying a Printer

There is plenty of information available in popular magazines and consumer guides about buying a home printer. Essentially, printers fall into two main categories: inkjet (these include dedicated photo printers)

and laser. As long as you purchase a printer that uses preservation-quality inks and papers, you can produce a good-quality photo print. The rest is personal preference. I like using a printer connected to my computer so I can download my photographs and then print them. Other people like using a stand-alone model and never put their digital images on their hard drive. These days you don't have to spend a lot to get a lot. The current photo printers are simple to operate, relatively inexpensive, and produce prints for about the same price as your local photo lab. Here are some things to consider before you buy:

Cost per Print

What is the actual cost per print based on paper and ink usage? Manufacturers usually know what it is per print. This doesn't cover user mistakes. Ink costs depend on the number of cartridges you have to replace at one time. If you can change individual colors separately, it will lower the costs.

Size

Printers range in size from compact models you can carry with you to those too large for a desktop. The final print size varies based on the dimensions of the printer.

Rules for Printing at Home

- Invest in a printer that uses preservation-quality inks.
- Print on acid- and lignin-free photo paper.
- Don't use regular ink and paper for your photographs.
- Keep track of the latest research and products on ‹www.wilhelm-research.com›.

If you need only 4 x 6 inch prints, you don't need a printer that can produce banners. Some of the smaller models produce only one size, but desktop models usually handle everything smaller than 8½ x 11 inches, and some come with rollers for oversize printing. You need to consider all the ways you'll print pictures before deciding on a single model.

Noise

I own two printers. One makes so much noise I try not to talk on the phone near it, while the other is quiet. Ask for a demonstration of the printing capabilities before you purchase.

Speed

When you read the specs for the model you're interested in, pay attention to how many prints it can produce in a minute. The faster the printer, the more copies it can produce in a set time.

Reading the Specifications: Photo Printers

Printer type: Dedicated photo printer or combination device.

Printer technology: Most photo printers are inkjet.

Paper handling: This refers to the size and type of medium that can be printed on, such as paper, photo paper, transparencies, and even printable CDs.

Ink type: Inks considered preservation quality are DuraBrite by Epson, Vivera by HP, and Pixma by Canon.

Pages per minute: Known as ppm, there is usually a rating for black-and-white versus color printing.

Resolution: Specs usually state the maximum dpi (dots per inch) for horizontal and vertical. Large numbers relate to higher resolution and photo quality.

Activity: Create a Family Photo Album

If you can tell a story with a single photograph, imagine what you can do with a whole photo album. Rather than filing all your photographs away for the future, organize some of them into an album. Look at other photo albums in your family for inspiration. In older albums, the order and placement of the photos is often deliberate, chosen by the person who created it. This intentional layout often told a chronological story of a family. You can choose to duplicate these efforts or arrange photographs by family group. The combination of simple labels with an attractive layout becomes an artifact that individuals can look at and appreciate. After you've completed an album, take it with you to family outings to show off your work.

Keep your presentation archival by purchasing albums made entirely from acid- and lignin-free materials from a supplier that markets to libraries and museums. A list of album manufacturers is in the appendix. Don't use adhesives unless you are using copies of original photos. Glues cause permanent damage. Photo corners made from acid- and lignin-free paper or from polypropylene are the safest.

Try out different layouts before finalizing your presentation. For ideas, look at contemporary wedding albums depicted in magazines. These layouts vary the size of the photographs within a page to attract attention to different details. Vary your photograph selection to incorporate black-and-white, color, and sepia to create an interesting presentation. Explore the possibilities offered by using photo-editing or publishing software to produce layouts that resemble magazine pages. Turn an ordinary family photo album into a spectacular product.

Documenting the Present for the Future

DOCUMENTING A FAMILY'S HISTORY is not just about collecting paperwork. It also involves gathering personal items such as artifacts, photographs, and even video history. Earlier generations employed artistic mediums like illustrated family trees and quilts as memorial pieces for their children and grandchildren because photography wasn't an option. Today, still and moving-image cameras are genealogists' tools of choice for preserving living family history.

This leads to an important question: Who is responsible for picture taking in your family? This job usually falls to the family member with the most equipment and interest.

Most families have a historian—someone who cares enough to appoint himself or herself as the guardian of the family's past. This person may or may not be the one who also adds to and maintains the family photo collection. Whoever it may be in your family, these industrious individuals need help. Contact them to see where they may need help in photo projects already underway. Offer assistance by sharing photographs or video footage you have taken. If there isn't already a family member in the position of family photographer, you can fill this vital role.

Become the Family Photographer

Anyone can become a family photographer. It doesn't take great skill, special photographic training, or expensive equipment. All you need is a desire to take pictures; the rest you can learn or purchase. Capturing the everyday moments and special events of one's family is a special task. Genealogy is about all the people, places, and things that relate to your pedigree chart. Photography is one of the best ways to bring "color" to what can otherwise be a very black-and-white story.

As you consistently provide photographs from family events, your reputation as a family photographer will grow, which will lead to opportunities to take more photos.

Learn a New Skill

Depending on your expertise with a camera, you might want to learn more about how to effectively photograph people and artifacts. You can do this by taking a class or by referring to manuals. Local universities and adult-learning courses often offer beginning photography classes. You can also find online tutorials and classes to help you hone your photo skills. There are plenty of photography manuals on the market. Stop at your local bookstore or camera shop and browse the offerings. Select a title that explains the topic in easy-to-understand terms and includes helpful examples. The rest is practice. Playing with your camera is one of the best ways to become comfortable using it. Set up a few trials using friends and immediate family members so

Anyone can become a family photographer.

that you know your camera's limitations and how to use it to take good pictures.

Use the Family Network

Once you're comfortable with acquiring a new role in your family, advertise it—not by taking out an ad in the local paper, but by bringing your camera with you to family events. After taking pictures, make copies for the relatives who sponsored the event. For instance, if you photograph a cousin's wedding, make sure the couple get copies of your images to add to their wedding album. The same is true for christenings, bar mitzvahs, and any other event. If you shoot digitally, post the images online on a family website or photo-sharing site so relatives can order their own prints.

Be sensitive to other photographers in the family. Again, if a relative has been photographing the family for years, ask how you can help.

What to Photograph

Wanting to photograph your family history is not about capturing every moment of a person's life. It's about creating a pictorial memory—one that reminds everyone who looks at it of the life of the individual photographed. It can be a single image or a set of photographs. It might be a candid snapshot, a collection of photographs, or a posed portrait. How and what you decide to photograph will vary from person to person. Before embarking on a photographic project, sit down and think it through. Managing such a task is the same regardless of the endeavor. First you have to know what you want to do, and then you need to follow through. Follow these steps to help you decide how to document your family with photographs.

Set a Goal

Start with the basics. Decide the nature and scope of your photographic pursuit. You might decide to create a photographic catalog of all the living members of your family or to just take pictures at family events. In either case, you'll have fun, meet "new" relatives, and be responsible for a family photographic archive. If you live too far away to pay them a visit, ask relatives to send you a favorite photograph of themselves.

If you happen to be invited to a milestone occasion like a wedding, remember to have your camera on hand to document the event. Take spontaneous shots whenever possible, but don't become the family

27

Add to your album by carrying a camera with you to family events.

Make a List

Setting out to preserve the present for the future requires a methodical approach, such as making a list of who you'd like to photograph. It helps keep you focused, plus you get to experience a sense of accomplishment every time you check off an item. Approaching your family history in the same way means you won't forget to document someone.

Missed Opportunities

The first rule of compiling a documentary family history is don't procrastinate. Delay interviewing a member of your family, and you might miss a chance to do so forever. Elderly relatives might not be able to recall the events of their lives or their families by the time you "get around to it." Individuals living in your area could relocate, making an interview or portrait an expensive proposition. Either take photographs at a family event, or set up an appointment to visit with each individual.

Study the Past

Look to the past for inspiration. For instance, what photographs of past generations in your home collection evoke the most memories for you? Are they the ones taken in professional portrait studios or those that

paparazzi, following relatives around to the point of being a nuisance.

Pictures are just the beginning. Bring along your family history notes and interview your subjects about their lives and genealogy so that you have the whole story as well as the photographs.

Photo Shoot Help

Practice your technique.
Show up late at a relative's house unprepared to take the picture, fumbling with equipment, lacking the right tools, or not having an idea in your mind about what you want to photograph, and it might be the last appointment you'll make. Word spreads fast in families, and it's likely that your one mistake will make it a lot more difficult to convince other relatives of your goal.

Be prepared.
Bring along enough equipment, film or memory cards, and your genealogical notes. Double-check your list of supplies so that you arrive with everything on hand. Think of every contingency. See "Be Prepared" on the following page.

Remain relaxed.
Not everyone is comfortable being photographed. If relatives sense that you don't know what you're doing or that you're nervous, they might change their minds. Reassure participants in your family history project about your intent. If you want to eventually publish the photographs (in a genealogy or online), get their permission in writing beforehand. Don't assume they won't mind.

Say thank you!
If a relative has set aside time to meet with you, remember to say thank you. Write a followup note, and enclose a copy of the photos.

depict a family member involved in an activity? Photographing the present can resemble the past. If there are photos of several generations of your family at work in the family business, then follow the trend and snap a shot of the present generation engaged in the same activity or endeavor. Those images tell a story.

Tell a Tale

Try to add interest to your photos by including props or color or by posing closely related individuals together. (You'll learn more about taking better pictures in chapter 4, "Taking Better Pictures.") Think about your subjects in terms of their hobbies, collections, and setting. If a

Be Prepared

There is at least one designated photographer in every family. If it's you, then you carry a camera with you wherever you go. It's worth putting together a kit of photographic supplies. Here's what you need:

Camera

Any model will do for photographing people; if you're going to copy family photographs or artifacts, a camera with a lens capable of close-ups is a good investment. It doesn't matter if your camera is a film, digital, disposable, or moving-image model. Tuck a single-use camera in your purse, carry bag, or briefcase so you're never caught without one. Don't store cameras in your car. Environmental changes will damage or destroy the camera.

Extra film and batteries

If you are using a film camera, keep extra film in your camera case as well as an extra set of batteries. Digital photographers need a spare memory card and a spare battery pack or set of rechargeable batteries. My camera uses AA batteries, so I can purchase new ones in most places.

Worksheets

Put a journal, small tape recorder, or worksheets in your kit so you can interview the family you photograph or learn more about the photos they've shared with you. These shot lists will help you identify the individuals and items later.

particular individual is never without a particular purse, then include that in the shot. Photograph relatives surrounded by their favorite things or in their favorite chair. Add visual clues to a relationship by photographing grandmothers with grandchildren or fathers and sons. Each photograph can tell a story of a particular relationship or of a family. It's all in how you choose to capture the story. Not every photo needs to be planned, so leave room for spontaneous shots.

For posed photographs, create a list of photos you'd like to have. A single portrait or candid shot of each grandparent would be on your list, but what about a photo of each set of grandparents or all of them together? If you have multiple generations of the women in the family, pose them together for posterity.

Label Your Photographs

The photographic moment doesn't stop after the photos are developed or when they are downloaded. There is no point in taking family pictures unless you plan to add documentation for each. Don't repeat mistakes of past generations by failing to identify the subjects in pictures you take now. It's easy to discard unidentified photographs, but those with information on the back can be given to interested family members.

Informative Captions

Suppose you decide to label a photograph as "Uncle S." because you have only one uncle with a first name that begins with an *s*. Then say in twenty years, a remarriage results in you having two uncles with *S* as the initial of their first name. It would be difficult to tell them apart. While you know who's who because you knew both of the men, your descendants may not. Labeling shorthand doesn't work and can result in misidentification later on.

Basic labels need at least a full name (including women's maiden names), life dates of the person(s) photographed, and the date the photo was taken. Try to caption all your photos as soon as possible so you

don't forget the data. Group portraits present a challenge because of the amount of information needing to be transferred. Photo-organizing software packages

Pose family members with historical artifacts to add interest to your images.

vary in the character length they allow. Do the best you can to include a complete label listing everyone in an image. New software such as *FotoTagger* <www.fototagger.com> allows you to add captions and identifying information to your digital image files.

Suggested Poses

- Children with their favorite playthings

- Children with artwork

- Intergenerational shots: mothers and daughters, fathers and sons, parents and children

- Grandparents

- Individuals posed with their houses or cars

- Activities (for instance, a gardener in the garden)

Other listed information might include:

- Geographic location

- Name of the occasion

- Negative roll number and image number

- Genealogical identification number from a software program

Careful Captioning

There are a few rules for labeling photographs. First, never write on the front of a photograph, to avoid obstructing details or damaging the photo. Keep identifying information on the back.

Second, use the right writing tool. Never use ballpoint or felt-tip pens. Ink can bleed through your photograph, causing permanent damage. Soft-lead pencils like those used for sketching are best for paper images, but most photographs today are printed on resin-coated (RC) paper that makes writing with a pencil difficult.

If you are trying to write on the back of a resin-coated image, then you'll need to purchase a special pen. Instead of using ballpoint pens that cause indentations and use ink that smears, invest in a pen made for writing on photographs. Any water-soluble ink like that found in felt-tip markers can damage photographs. Permanent markers are not necessarily suitable for photographs. Use pens labeled waterproof, fade resistant, permanent, odorless (when dry), and quick drying, such as Zig markers. You can purchase these writing implements in most art supply and scrapbook stores. Use black ink whenever possible, since some colored inks fade with time.

You're probably thinking all this advice is useful for prints, but what about slides, negatives, and digital photos? Here are a few techniques to help you label specific types of photographs.

Heritage Photos

Use a soft-lead pencil, and lightly write the identification on the back.

Contemporary Paper Prints

Place the photograph face down on a clean, hard surface, and write using an appropriate pen, such as a photo-safe, fine-tipped permanent marker. Do not press down on the photo, or you'll cause indentations.

Slides

Store slides in appropriate plastic sleeves or pages (polypropylene or Mylar), and label each mount with pertinent information. Fine-tipped pens that work on resin-coated photographic prints can be used to label both paper- and plastic-mounted slides. You might not be able to fit the entire caption on the small area available on a slide. Maintaining a separate log for each uniquely numbered slide should help.

Negatives

Negatives are similar to slides—polypropylene or Mylar sleeves work, as do acid- and lignin-free enclosures. Write identification data on the polypropylene pages

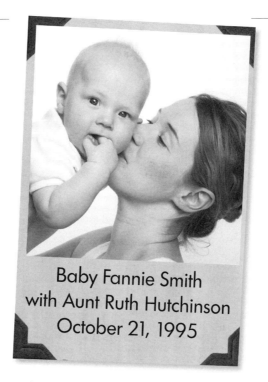

Baby Fannie Smith
with Aunt Ruth Hutchinson
October 21, 1995

Label all your images as soon as possible so you have a record of who is pictured and where and when the pictures were taken.

33

made for negative storage with an appropriate pen. Label the negative storage sleeve, envelope, or page so you'll know which roll of film it goes with. Instead of naming each person depicted in the negatives, include a note of what's on the roll and a span of dates for the photographs. Number each roll of negatives, and consider placing that number in the upper right-hand

corner of the photo so you can easily retrieve the negative when you need additional prints.

Digital Images

Most photo-organizing software on the market lets you caption images using keywords, making your entire collection of electronic images searchable. Use this software for all your digital images, regardless of whether they were taken with a digital camera, downloaded from a family website, or scanned. A new product on the market allows users to tag and caption their digital images. It's a free download from <www.fototagger.com>.

Types of Projects

Family history is an active hobby, and so is photography. Genealogists don't waste time waiting for information to come to them. Most seek out the past in a variety of ways, such as talking with relatives and gathering data. If you're the family photographer, then you'll be on the move, snapping pictures for posterity. There are numerous genealogically oriented photo projects you can do, from crafts to illustrated family histories.

Activity: Create a Family Photo Archive

Begin by examining your genealogical research. Do you have a recent photograph of every living person on your family tree? Starting a large archive project requires answers to five basic questions.

Who to Include?

The answer to this question defines the extent of your project. There are different types of genealogies, such as those that follow direct lines of descent or those that trace all descendants forward. To create a photo archive, you need to decide who to include—everyone, including children, or just a certain group. Create a checklist of individuals you want to photograph organized in a logical fashion, such as by surname or by family group sheet. Select a system that works for you.

Why a Photo Archive?

Why select this type of project? Well, perhaps you want to know what everyone looks like. Other people like to collect photographs so they can fill in missing details in their family history. Acquiring photos of family is similar to locating other types of genealogical

documentation. A photograph provides another source of information.

How Will You Do This?

Is it possible to actually accomplish this goal? Sure! Even if you don't succeed in snapping pictures of all your living relatives, you'll still have an extensive collection of photographs worth preserving. Creating a photo archive for your family is something that interests even the non-genealogically minded relatives.

Where?

This actually breaks down into two separate questions. Where will you photograph these individuals, and where will you store the archive? Obviously, you don't want to have to travel all over the country to visit myriad relatives, so plan photographic opportunities to coincide with anniversary parties, reunions, and other family get-togethers.

Store digital images in genealogy programs attached to information on the family. The multimedia components of genealogical software programs act as an organizing tool. One idea for actual photographs is placing them in acid- and lignin-free boxes and polypropylene

sleeves in an area with stable temperature and humidity. Do not stack photographs. An ideal storage area in a house is an interior closet (one without an exterior wall), away from windows and pipes.

Finding the Time?

It's easier than you think. Finding time to take pictures shouldn't be an issue if you incorporate your goal into

Create a family archive of your photographs, and add some from your relatives as well.

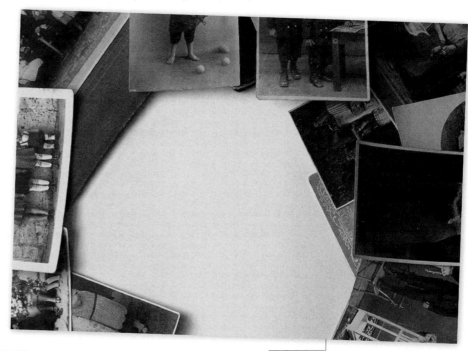

35

a regularly scheduled event. If you are going to attend a family function, take along your equipment so that you'll be ready for spontaneous moments and to add new photos to your archive.

Creating a family photo archive is a never-ending project. Each new baby will need to be added to the collection. Update the content of the archive by including photographs of individuals taken every few years. Try not to discard earlier photographs; instead, use them later to profile a person. Family will seek out your collection to create collages at weddings and funerals so that attendees can see their lives in photographic perspective.

Organize Your Photographs and Data

Don't let your digital images languish in unidentified files—the equivalent of a digital shoe box. There's a good chance you won't remember all the specifics—who, what, and where—years later. It's not very complicated to arrange these images. There is an assortment of software on the market to help you do this. *Picasa* <www.picasa.com>, a free download from Google <www.google.com>; *Adobe Photoshop Album*, which can be downloaded from <www.adobe.com>; and Corel's

Photo Album are three popular programs that locate all your digital files, including scanned images, and organize them into albums. Forget lost photos. You can eliminate those annoying numbers assigned to each photograph and add keywords, making it a cinch to search for all the electronic images of one family member or event. Once you can find a photo, you can use it to make gifts or incorporate it into your family history. Genealogical programs like *Family Tree Maker* <www.familytreemaker.com> have multimedia features that let users attach images to genealogical data.

Storing Prints and Negatives

Prints and negatives require care if they are going to last a lifetime or even longer. It isn't hard to locate expensive supplies to protect your photographs, but all you really need are a few commonsense rules and some photo-safe materials.

Handling Techniques

Wear clean, white cotton gloves when handling photographs, or at least wash your hands with soap and dry them completely. No matter how clean you think your hands are, there are oils and substances that transfer to

the surface of any photograph you handle. Handle all types of photographs and negatives by their edges only.

Finding Space

The areas usually utilized for storage—basements, attics, and garages—experience fluctuations in temperature and humidity. Those environmental changes deteriorate your photographs and encourage pests to nest and mold to grow. It bears repeating that the best place to store your photographs is in a windowless closet in your home, away from water pipes and heat sources. Photographs last longer in areas with stable temperature and humidity.

Storage Containers

Purchase materials from reputable suppliers that sell to museums and libraries. Make sure supplies are free of both acid and lignin (the chemical that causes newspaper to yellow) and that the plastic overlaps are made of polypropylene or Mylar. Some art supply or craft stores also carry similar materials. Boxes with reinforced corners prevent buckling when stacked.

Albums

If you want to use photo albums, the same rules apply. Never place your photographs in albums identified as magnetic. They contain adhesives that will damage your photos. Use albums with acid- and lignin-free paper pages and polypropylene page protectors with photo corners made from similar materials. Do not

How you store your photographs affects how long they will last. Look for acid- and lignin-free supplies.

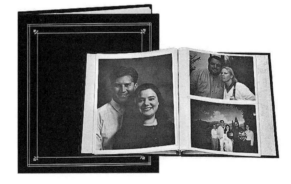

37

Photo Sharing Options

- E-mail electronic photos to relatives.
- Create gifts from favorite photographs.
- Copy photos to a CD and mail them.
- Download your digital images to your iPod and carry them with you.

glue your photos into an album. The adhesive eventually damages your pictures.

Sharing Images

This is one of the best things about digital imaging. You can send a photo to anyone in the world with a single mouse click. While storing digital images in a TIFF format preserves the image quality, it is not a convenient format for e-mailing because of the size of the file. Convert your image files to JPEG for quick downloads, or select the compress feature in your email program. You can send electronic images by attaching them to an e-mail, or use photo-organizing software that lets you send whole albums. Additional information on photo sharing sites appears in chapter 6, "Get the Whole Family Involved."

Documenting your family history through photography is exciting, lively, and lasting. It takes a camera, imagination, and a sense of history. You'll be creating a visual history of your family one photograph at a time.

Taking Better Pictures

THERE IS A MEMBER OF MY family, who shall remain nameless, who can't seem to take a good picture. Either her finger ends up in front of the lens or pieces of individuals end up missing. Diagnosing these two problems hasn't been easy. I've watched her take pictures and gently tried to correct these simple errors. But time and again her photographs return from processing with a major flaw. These mistakes are common and correctable. My relative simply needs to gain experience behind the viewfinder and learn how to use her camera.

Most photography problems are due to inexperience or unfamiliarity with the equipment. Even if you're using an easy-to-operate camera, it doesn't guarantee that you are a perfect shot. A well-composed photograph is the result of the relationship between the camera and its user. It's a partnership. The camera comes with a set of features, and the photographer needs to know how to make the most of those tools. If the process were foolproof, there wouldn't be a need for books and videos to help amateur and professional photographers.

A trip to a bookstore will convince you that you're not alone in trying to getting the best shot. You'll find shelves of how-to books for photography and multiple

magazines that include columns and features on improving picture-taking skills. Let's start with the basics.

Seeing the Final Photo

Professional photographers often talk about developing a photographic eye. This means being able to visualize a photograph before taking it and being able

to understand what makes a good picture. So what makes a photograph worth keeping? Clarity, composition, and subject are important factors in family photographs. A blurred photograph of the eldest member of your family may be well composed and attractive, but it doesn't provide descendants with a clear portrait. I'm not suggesting that all family photographs have to be focused. Some soft-focus techniques convey mood and feeling. However, if your intention is to document a family, then a single out-of-focus shot isn't representative of that person.

No one reading this book can deny that we live in a visual society. We are bombarded with photographic images—still and moving—every day. Magazines, television, newspapers, the Web, and even books all use photography for different reasons. But does being confronted with photographs daily enable you to tell the difference between an outstanding shot and an average one? Perhaps. It's just my opinion, but I think anyone who wants to photograph family history should be familiar with pictures taken throughout the medium's history from 1839 to today. It exposes you to all types of photos and might inspire you to look differently at your family history picture taking. Students studying to

be professional photographers usually have a required task list that includes looking at photographs as well as taking them. The point of viewing photographs is to educate your eye and brain—to learn how you compose shots through the viewfinder or lens.

Assignment One

Visit your public library and browse the shelves for photo books. Critically look at each one, assessing your likes and dislikes. You'll likely find that you admire some and hate others. Think about why you like one and dislike another. All this looking develops a sense of the basic components of a picture. Trying to duplicate the pose and look of a famous photograph is one way to practice your picture-taking skills.

Read the Manual

While the previous assignment is optional, this one isn't. In earlier chapters, I've mentioned that reading your camera manual is essential to learning how to make the most of your equipment, yet how many people actually do it? The majority of consumers buy a piece of equipment, take it out of the box, and try to use it without reading the directions. Only when they can't locate a

particular control do they seek out the manual (if they can still find it). If they were taking a test, it would be an automatic failing grade. What's one of the first skills you're taught in school? *Read the directions*. Manufacturers spend thousands of dollars hiring technical writers to produce manuals for equipment, but most of us just skip to the picture-taking part. Reading the manual with your camera handy allows you to become familiar with all the features you paid for.

Assignment Two

Take out your camera manual and learn one new thing about your camera. Then take a picture using that feature.

Practice Makes Perfect

Learning to operate your camera takes practice. Expect to use film while you're playing with all the features. However, you won't incur film costs if you use a digital camera. You can delete your mistakes over and over again without incurring film or processing charges.

Think of your camera as an instrument. You'll only get better at picture taking with practice. Before taking a research trip to photograph family, documents,

Camera Manuals

Lost the manual? Locate old camera manuals online by searching auction sites like eBay ‹www.ebay.com› or by contacting companies that publish old manuals online or sell originals or copies. For newer cameras, contact the company that manufactured the camera, or visit the manufacturer's website to see if a PDF version is available to download.

eBay

‹www.ebay.com›

Search by entering the manufacturer and model number or "camera manual."

Henry's

‹www.henrys.com/manuals›

This is a guide to camera manuals available online. Links on the site take you to *Adobe Acrobat Reader* PDF files to download and print. You'll need *Adobe Acrobat Reader* to access these manuals. It's available as a free download at ‹www.adobe.com›. Some links take you to a manufacturer's site.

and heirlooms, waste some film at home trying out the techniques so you'll return home with usable photos.

Assignment Three

Explore the versatility of your equipment. Try photographing people and things in different lighting situations. You'll find photo techniques explained on your camera manufacturer's website. You could also take a class online or at a local camera shop or college.

Composition

Turning a real-world experience into a memorable two-dimensional photograph involves composing the photograph. Composition, or arranging the elements of a scene, can create a great photo that emphasizes the subject, or it can detract from it. It's all about what you include and exclude from your photograph. There are many ways to photograph the same person or location, and each will create a different image because of how you frame the shot.

Pick a Perspective

What are you trying to highlight in a photo? Placing people in the foreground (the part of a picture closest to the viewer) creates a different effect than putting them in the background (the area farthest from the viewer). Try both before deciding which view to use. While

camera viewfinders or LCD screens are horizontal, there is no reason why you can't consider taking a vertical shot of a scene. Add variety to your photos by taking some verticals as well as horizontals. Another option is to focus on the subject in the foreground so that the background is blurred. It brings attention to your subject without the distraction of what's behind it.

The Rule of Thirds

Composition is also about balance. Placing a subject in between two similar items creates a symmetrical photo, while placing it in one corner or another creates a diagonal and draws the viewer's eye across the shot.

The rule of thirds divides a picture into nine equal parts. Significant parts of a picture are usually placed at intersecting grid points. Try thinking of your photographs as having nine sections. Position details at the points, and see how that changes the emphasis of your photo. It can add interest and balance to your photographs.

Take Lots of Pictures

Family photographers usually take one picture of a person or a scene and think, That's it, I've got what I

needed. Professional photographers usually take several different shots of the same scene or person to see different results. Focus on details, vary your camera angle, and think about ways to compose your photograph. Not every one need be a "keeper"—one worth putting in the family archive or album. Film is relatively

inexpensive, and digital memory is free (once you buy a memory card), so don't be afraid to experiment. You might decide that your fifth or tenth shot is better than your first. You'll be glad you took the extra pictures.

Watch for the Spontaneous

You don't always have a chance to shoot a spontaneous moment. In family photographs, it could be a once-in-a-lifetime chance to catch a person interacting with another. Carry extra film or memory cards to enable you to make the most of these chances.

Set Up Your Shot

Rather than rely on an accidental moment, try arranging your photographs. Think about what's in the foreground and background, and use the details to your advantage. For instance, pairing individuals with similar clothing colors together against a contrasting background documents the couple *and* creates an interesting composition. Prepare for a photo shoot like the pros by making a list of the shots you want to take.

Think of Alternatives

Here are some of the ways professional photographers create fabulous photographs:

- Background—Choose a setting that complements or contrasts through color, texture, or patterns.

- Reflections—Capture your subject as it's shown in a reflective surface, like water, glass, or metal.

- Lighting—Just as the time of day can change the appearance of your subject, so can different types of indoor lighting that have a color cast.

- Texture—Think about the textures present in the scene and then contrast them.

- Color—Some colors complement each other, while others provide contrast, such as white and black or red and green. Try different color combinations using sheets of paper to see how you can create different effects using color.

Use Props

Whether you're taking a picture of a relative or a group of artifacts, props add detail and information to a photograph. Pose a person with his or her favorite things, or arrange artifacts by size against a background.

Don't Fear Mistakes

Repeat to yourself, "No picture has to be perfect." That's why there is extra film and additional memory card space. It's also why photo-editing software is so popular. You can usually take a picture a second, third, or sixth time. Don't set unrealistic picture-taking expectations for yourself. Photography requires practice.

Activity: Composing a Shot

Here's a fun exercise: Try looking at what you'd like to photograph in different ways. The next time you decide to snap a picture, try this exercise to explore other options for capturing your subject. (See also the suggestions in the "Points to Consider" section of this chapter.)

- Walk around a room in your house looking at it either through your camera's viewfinder or lens or by "creating" one by overlapping your thumbs and pointing your index fingers up. This activity helps you experiment with framing. You'll discover that certain "frames" look more interesting than others.

- Try placing your subject in a variety of settings. For instance, if your relative is wearing bright-colored clothes, sit him or her in front of a contrasting color background to create a dramatic shot. If you've posed someone in front of a busy wallpaper, try moving to a solid-colored wall and see how it changes the scene.

- Explore how your photograph might look if you were to take a vertical rather than a horizontal photo. Most of us tend to shoot horizontally. Turn your

Photo Terminology

Backlight
Lighting a subject from the back appears as a halo around a person's hair in a portrait, but a subject backlit outside results in shadows. You can eliminate the shadow by using a flash.

Bracketing
The process of taking several shots of the same scene using different settings to ensure you get a good picture.

Contrast
The balance between dark and light areas in a photograph.

Generation
Just as in genealogy, there are generations in photography. The first generation is a copy of the original print; a copy of that copy is the second generation; a copy of the second is the third. Each generation of a print results in a less clear image. This loss of quality doesn't happen when making exact copies of digital photos.

Grain
In low-light pictures, grain is visible as small dots that make the picture appear fuzzy. In digital imaging, this is referred to as noise.

camera to look at how the change in layout affects your photo.

- Before you snap the shutter, step closer to your subject or zoom in. Instead of seeing a lot of distractions in your photograph, you'll focus on the important part—your subject.

Common Errors

Everyone tries to take better pictures, even professional photographers. Let's review the most common mistakes and what you can do to make your photographs picture perfect.

Finger or Hair over the Lens

This type of mistake often happens with inexperienced photographers using cameras with viewfinders. Your finger is over the lens, but you can't see it because the viewfinder only shows the user the scene shown in the viewfinder rather than the image taken with the lens.

Correction: Try different ways of holding the camera so that nothing obstructs the lens, and double check before you push the shutter.

Part of the Scene Missing

This is most common with point-and-shoot or single-use cameras that utilize viewfinders for framing the photo. What you see through the viewfinder isn't always what you get. You can easily lose edging around the photo, which can result in the loss of parts of your subject.

Correction: Try centering your subject, leaving open space on either side to account for viewfinder error.

Incorrect Focus

This could be several problems. Autofocus cameras usually focus on the center of the photograph, so where you point the camera will be in focus, but anything on either side of the focal point may not be. For instance, you're trying to photograph two people standing side by side with a backdrop like a wall or flowers. If you point the camera directly at the flowers, you'll end up with a clear image of the background but not of your subjects.

Correction 1: Point your camera a little off center so it focuses on the subjects rather than the background.

Correction 2: Some cameras are equipped with a selectable autofocus feature—often called "multi-area AF" or "dynamic area AF." If your camera is so equipped,

you can make the camera's autofocus system focus on a subject that is not in the center of the frame.

Blurred Subject

Either the subject moved, the film speed is too slow for the shutter speed you're using, or it's a result of digital lag (time between shutter-click and when the camera

captures the image). Another possibility is operator error. If you move when taking the shot using a slow shutter speed and/or the wrong film, you'll end up with a blurry photo.

Correction: Try using a faster (i.e., higher ISO—see page 16) film or a faster shutter speed. Use a tripod with a shutter release cable to minimize movement. If the problem is with your subject, ask the person to sit or lean on something steady for support.

Photos Too Dark or Flash Problems

Lighting problems fall into different categories and usually depend on whether you are using a built-in flash or one that is an accessory. Often, amateur photographers forget that all flash units work within a set range. Go outside that area, and the flash has no effect. For instance, if you try to take a picture of a grandchild on stage and you're sitting several rows back, the flash will only illuminate a few feet from the camera and won't reach the stage, leaving the child in the dark. Nearby objects receive more light because they are closer to the source of the flash.

Correction: Add an accessory flash to your camera and extend it so you can better control lighting. If you

Staying Still

There are several ways to prevent blurry images due to inadvertent movement. At slow shutter speeds in low-light situations, it can be very difficult to stop small movements from affecting your pictures. Try one of the following to avoid that problem. (It can be helpful to use a cable release with these methods.)

Lean on a solid surface.
Use a doorjamb, a camera case, a box, the floor, or a level rock outside as a stabilizing tool.

Use a table clamp.
Purchase a small clamp that attaches to the bottom of your camera for use with any surface with an overhang.

Carry a tripod or handgrip.
Handgrips and tripods also attach to the bottom of a camera. Tripods come in different sizes, from tabletop models to those that reach eye level. Both devices enable you to take pictures without actually holding the camera.

Purchase a digital camera with image stabilization.
There are many different models currently on the market in all price ranges.

50

point your flash up toward the ceiling, you'll get a more evenly lit photograph.

Red-Eye

Do your photographs of family members resemble characters from a horror film with glowing, red eyes? This is what happens when the retina of the person looking at the camera reflects the flash.

Correction: Newer model cameras often come with red-eye correction, which means your camera actually flashes twice. The first flash tricks the eye so that the reflection doesn't occur. Most photo-editing software packages allow users to fix red-eye, just in case you don't have an automatic camera correction.

Never Part of the Family Portrait

If you find yourself left out of family photographs, you haven't tried to use the self-timer that comes standard on most cameras.

Correction: The exact time varies from model to model, but all you need to do is read the manual to find out how to use this feature on your camera. For best results, place your camera on a solid surface, set up the shot by looking through the viewfinder, set the timer, and run to your spot in the family photo.

Trees Growing Out of Heads

Several years ago, my husband took a picture of me smiling in front of a giant, plaster artichoke. The artichoke, thorns and all, looms behind me in a threatening way, making me seem part of the object. It's actually a pretty funny photograph, but this isn't always the case. Whenever you have a shot where a tree, telephone pole, or plant seems to grow out of your photographic subject, it's a case of false attachment.

Correction: Avoid this by standing your subject beside the larger object or by focusing on the person and blurring the background.

Taking Better Portraits

As the family photographer, you'll probably be taking more pictures of people than anything else. By following these simple tips, you can take good photographs of all the members of your family, from the youngest to the oldest.

Rule One: Avoid light that makes people squint.

That means posing people so they aren't looking into direct sunlight. Squinting or frowning to avoid looking into the light is unattractive. You won't be happy with the results, and neither will they.

Rule Two: Avoid distracting backgrounds.

Try to see your photograph as divided into the rule of thirds, with no one section overpowering another. If you pose someone in front of a bold, colorful, textured background, you're apt to lose sight of your subject.

Rule Three: Try different perspectives.

It is possible to change the appearance of a person's facial shape based on camera angle. For instance, posing a person so he or she is turned toward the camera at a three-fourths angle narrows the face. If you take a picture shooting up toward a person's face, you'll emphasize the nose and the nostrils. Most people really do look slightly different from one side of their face to the other. Faces are asymmetrical. Try various angles and perspectives until you find one that is flattering. Also, ask your subjects to try different expressions to capture their personalities.

Rule Four: Relax your audience.

Not everyone is comfortable being photographed. If the subject of the portrait is worried about her hair, whether she has things in her teeth, or her latest adolescent outbreak, you're going to have difficulty getting her to look relaxed in the photograph. Carry a comb, dental floss, and a small mirror with you so your subjects can check their appearance before you photograph them. Let kids and adults clown before the camera so you can catch them in relaxed and spontaneous moments.

Special Case: Groups

Any photographer knows that photographing a group is more difficult than taking a picture of a single person. Someone always blinks or makes a face at the wrong moment. Try these tips the next time you have to photograph a group.

Take More than One

Always take more than one picture. You can't possibly keep track of everyone's expression in a group photo, so take multiple shots of the same posed group.

Try to Prepare Beforehand

Set up your tripod before people arrive so they aren't waiting for you. Children are easily bored with standing around. If too much time elapses you'll have trouble controlling the members of the group, who'll be impatient to move on to other activities.

Get Their Attention

Do whatever it takes to maintain group focus, even if it means making funny noises or donning an odd hat to get their attention while you push the shutter.

Take Different Types of Photos

Instead of focusing on getting a posed group portrait at the next family gathering, try mixing up the shots.

Spontaneous Groups

Take pictures of family members engaged in an activity or quietly talking. It may mean snapping more pictures of small groups, but you'll still manage to photograph everyone.

Small Groups

Split the family into smaller groups. For instance, single out a generation, or put nuclear family members together. There are endless possibilities.

Forget the Formal

Use elements of your setting, such as simple backgrounds, in the photograph to add pictorial interest. Try not to pick settings that are too distracting, such as

a backdrop of colorful flowers. They will compete with your subjects for attention.

References

Ang, Tom. *Digital Photography: An Introduction*. 2nd edition. New York: DK Publishing, 2007.

Hedgecoe, John. *The New Manual of Photography*. New York: DK Publishing, 2003.

Photographing groups is particularly challenging because someone always blinks at the wrong moment. Take several different shots to guarantee you'll get the picture you want.

Tips for Taking Better Pictures

Know your equipment.
Read the manual, play with the gadgets, waste film (or memory card space), but do whatever it takes to become familiar with all the bells and whistles on your equipment.

Change your orientation.
Try the same picture as a vertical or as a horizontal shot. A typical family photographer takes most images as horizontals. Mix up your family album with a few vertical shots.

Get closer.
Don't stand twenty feet away and try to get a great shot. Try standing closer or zooming in on the scene to see if it improves the shot. Don't be afraid to get closer to your subject.

Try another format.
Always shoot in color? Try using black-and-white film, or select that option (or other color options) on your digital camera.

Enjoy yourself.
If you're stiff and nervous about your photography, you'll make people uncomfortable. Take five deep breaths and relax. Take plenty of pictures so you don't get locked in to having to get the first one right.

Frame-worthy pictures.
Probably only a few of your pictures are worth displaying right out of your camera. Take time to try a few of the special effects offered in a photo-editing program. You'll be able to turn an ordinary image into a work of art. Even professional photographers don't take a perfect shot every time.

Learn from the pros.
Did you know that posing heavier people in the middle of a group portrait actually makes them appear slimmer? Neither did I, until I read it in a photo magazine. Subscribe to at least one photo magazine and read the articles. You'll pick up lots of tips!

Langford, Michael. *Learn Photography in a Weekend.* New York: Alfred A. Knopf, 1992.

Photo-Editing Improvements

If you've tried your best and still have less than perfect photos, try fixing your mistakes using photo-editing software. You'll be able to remove red-eye, sharpen slightly blurred images, crop photos, cut and paste people into shots, and add special effects. Try your favorite photos in different formats—black-and-white or sepia—or turn them into a painting using a watercolor effect. All it takes is a digital image and a software package, and you're ready to try improving your photographic mistakes the digital way.

Read the Reviews

Computer and consumer magazines publish reviews of new products, and at least once a year they offer an overview of all the new ones in a particular category. *Consumer Reports* and *PC World* are good print sources of information. Online publications such as About.com and ZDNet.com also compare products. Check out the results of their testing before actually purchasing an additional piece of software. You can find out

how other consumers rate products on Epinions.com. If you use a particular photo-editing product already, add your own review.

The decision to invest in a photo-editing software package should take into account your familiarity with using photo-manipulation products and your budget. Also consider how you're going to use it. It isn't necessary to buy a sophisticated graphics program if all you're going to do is correct color or fix red-eye. However, if you decide you want to merge several different digital images or create a family magazine, a more versatile product might be worth the investment of time and money.

Pick a Product

Before purchasing a photo-editing product, find out if you already own one. Editing programs come packaged with digital cameras, scanners, and photo printers. More recent operating systems offer users photo- and video-editing elements. Photo-processing sites online usually offer minimal photo-editing tools to their customers as well. Many new computers come with editing software already installed. While you won't use all of the photo-editing programs at one time, try them all before deciding which one fits your skill level and needs.

Research the Software

Vendor websites include specifications, key features, and examples of how to use the product. Some offer trial downloads so you can try a program before you buy it. Most don't require a credit card number to use a trial version. While you can order the product through the company's website, try shopping around for a better price. Web comparison shopping sites help you locate the best price for the product and vendors with a high customer satisfaction rating.

Top-rated Programs

Basic features include cropping and editing tools, red-eye elimination, and rotation options.

Microsoft <www.microsoft.com>

Microsoft sells three well-reviewed products in its digital imaging line: *Picture It! Premium, Digital Image Pro,* and *Digital Image Suite.* The user-friendly Web page encourages consumers to learn more about the product and try it with interactive product tours. Online user manuals let you see explanations about using the features. System requirements for each product appear on the website.

Picture It! Premium

- Photo organizer
- One-click photo fixes
- Mini Lab—allows user to fix multiple photos simultaneously
- Editing tools
- Printing tools
- Templates and clip art for cards, calendars, and other graphic projects

Digital Image Pro

Includes all of the above features, plus:

- Digitally stitch multiple photos together to create a panorama.

- Eliminate noise (random pixels) for better clarity. Use "Smart Erase" to cut unwanted objects from images.

- Take advantage of advanced editing tools.

- Includes additional templates and clip art.

Digital Image Suite

Includes all the features of *Digital Image Pro,* plus:

- Use the photo organizer to categorize and find your digital photographs.

- Turn your photos into videos with Photo Story.

- Flag photos for editing or printing.

Adobe <www.adobe.com>

Adobe digital imaging solutions fall into two categories: those for the average consumer and those for artists and designers. Cost and features differentiate these digital-imaging products. Free downloads of the full product are available; they expire thirty days after installation.

Adobe PhotoShop Elements

- Separate packages work with Windows and Mac operating systems.

- Smart Fix automatically fixes lighting, color, and contrast, then lets you make additional adjustments.

- Quick Fix shows before and after views of changes.

- Scan multiple photos at once. The product divides the group and saves the photos separately.

- Compare color variations.

- Use the Spot Healing Brush to eliminate wrinkles and distracting objects.

- See the whole palette of colors in your photo to make adjustments.

- Create custom slide shows and composite images.

Adobe PhotoShop Creative Suite

Includes all of the features of *PhotoShop Elements*, plus:

- Professional retouching, painting, and drawing tools.

- The ability to separate your photographs into layers, such as foreground and background, and to manipulate each layer.

- Special effects filters.

Corel Software <www.corel.com>

Corel consistently competes with Microsoft and Adobe for a share of the digital imaging market with its *Paint Shop Pro*. It usually appears in comparison reviews with the aforementioned products. *Paint Shop Pro* offers tools for photo editing, graphic design, and digital art. A free trial is available for download.

Corel Paint Shop Pro

- Color correct photos.

- Edit, fix, and repair photos.

- Manipulate composition of photos.

- Improve clarity.

- Use the fill flash filter and backlighting filter to correct exposure problems.

Cameras and software help you become the best family photographer possible, even if you have little experience. Take a picture and fix it later, or play with

your camera features as you shoot a scene. Either way, the photographic marketplace, with products marketed toward the average consumer, enables anyone to become a better photographer.

Activity: Create a Photo Biography

If the thought of documenting an entire extended family is overwhelming, try creating a biopic of a single relative or couple. A biopic is a pictorial biography of a particular person or family. This is usually done for couples celebrating an important anniversary or for a special grandparent, but you can create a biopic of anyone you want. The photographs can be organized in several different ways.

- Combine a series of older photographs and newer ones into a sequence from birth to the present for a life story. This requires photos of the subject of the biopic at certain significant milestones, as well as new and old photographs. Enlist help from a close relative of the person you are featuring so you can include older photos and anecdotes about them.

- Another option is to use only contemporary photographs and group them by topic, such as children, grandchildren, and activities.

- Position a single photograph on a page, or put a series of related photographs together for a layout. Investigate using photo-editing or publishing software to help with the presentation.

- Include a lengthy caption with genealogical detail, reminiscences, and insights by other family members.

Visit any local bookstore to take a look at the latest biopic of a famous person to help you decide on layout options and presentation.

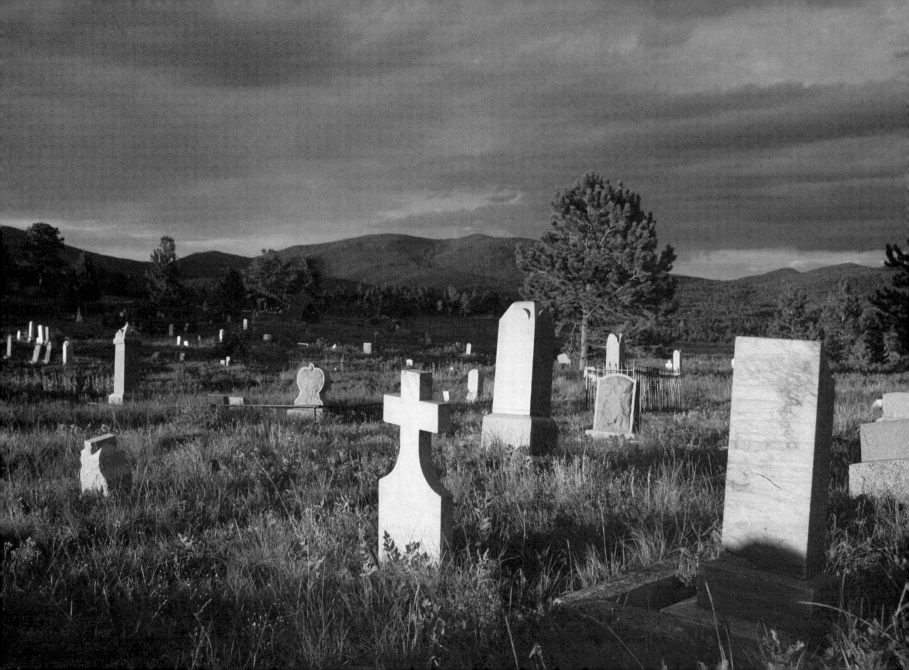

Photographing Gravestones, Heirlooms, and Documents

THINK OF YOUR CAMERA AS A genealogical tool in the same way that you use a photocopy machine or a scanner. A camera helps you take your research home. Use it to photograph documents, catalog family artifacts, or capture genealogical details from headstones. You'll be amazed at how photographs can augment your note taking. In addition to photographing relatives, knowing how to take pictures of artifacts and documents is a handy skill. It just takes practice, a few accessories, and a bit of common sense.

Gravestones

There is so much misinformation available on the right way to document a gravestone marker that it is a wonder that any markers are still standing. These monuments to our ancestors, when properly maintained, are permanent reminders of a loved one. Unfortunately, a lot of damage is innocently done in the name of preservation. For instance, the common practice of creating a rubbing is actually harmful and in some states is illegal. Many school groups studying local history make rubbings of gravestone markers to use in the classroom. However, rubbings are abrasive and damage the surface

of the stone by eventually wearing away the carving or loosening bits of soft stone. Even the most careful and gentle rubbing results in decay.

Photography offers an alternative. With the right equipment, bright sunlight, and a little patience, you can use photographs of headstones for educational purposes or add them to a family photo archive.

Taking a picture is an ideal way to document the information on the stone without causing deterioration. You will be able to share your discoveries with other researchers. You can also transfer the gravestone images into a genealogical software package, thus adding depth to your genealogical data.

Preparing for the Trip

Every research trip requires some preparation to ensure you've brought along everything you need. Before visiting a cemetery to photograph stones, review your genealogical research to verify where your ancestors are buried. Then make a list of all the stones you hope to find on your trip. While you won't necessarily be able to contact owners or caretakers of some smaller or older cemeteries, I'd call large cemetery offices ahead of your visit to ask about accessibility and policies. The town or city hall should be able to supply contact data for municipal facilities as well as some privately owned ones. Purchase a detailed map of the area to help locate burial grounds. If you're using information from an old transcription, many of the markers or roads may have changed. Call the local historical society before leaving home to double-check the location.

Photo Basics

Photographing gravestones takes planning, especially if you have traveled to visit the family burial ground. A successful photo shoot is coordinated and well equipped. Start by organizing your research notes and gathering supplies. Once you've arrived, you may have to wait several days for the right combination of factors such as light and weather in order to take the best possible photographs. Rushing any part of the photographic process will generally result in poor-quality photos.

Light

Bright sunlight is necessary to highlight the stone's features. Ideally, midday sun that hits the stone at a thirty-degree angle is best. Other types of sunlight emphasize imperfections in the stone and can make the carving look flat. The stone's location influences when the best possible photo might be available. For instance, gravestones in New England often face west and are best photographed at midday, while stones that face north should be photographed in the late afternoon. Those facing south are well lit all day in midsummer but not during the rest of the year.

You can improve the quality of light by reflecting it with a mirror to highlight the stone and carving. A plastic, full-length mirror works well. Ideally, the stone should not be taller than the mirror. If you are focusing only on a section, then a small mirror can be used. Since you will need to position the mirror, it would be helpful to have either a partner or a tripod with you. If the sunlight is too strong, you can create some shading either by standing in front of the direct sunlight or by using a large dark cloth or piece of cardboard as a shield. If the stone is located in the shadows, you may be able to use two mirrors to help you reflect light. Keep in mind that you still need a sunny day.

Composition

Well-known gravestone photographers Daniel and Jessie Farber spent fifteen years photographing thousands of stones and wrote a guide on the subject, *Field Guide to Photographing Gravestones* (1990), for the Association for Gravestone Studies <www.gravestone-studies.org>. The Farbers stress that composition and creativity should be part of photographing tombstones. They advise "taking advantage of various weather conditions, such as fog, snow, even moonlight, as well as

bright sunlight" for creative picture taking. Follow their advice, and your photographs might end up suitable for framing. Their images are available on CD-ROM as the *Daniel and Jessie Farber Collection of Gravestone Photographs* (American Antiquarian Society, 1998) and online at the Farber Gravestone Collection <www.davidrumsey.com/farber>.

Equipment

Type of Camera: Film vs. Digital

A 35 mm SLR that is outfitted with either a 50–55 mm lens or a wide-angle 35 mm lens for crowded areas is a good choice. Smaller lenses will distort the straight lines in the photo. A zoom lens is an optional piece of equipment, but I'd carry one to have the ability to take closeups of the stones.

Digital cameras let you preview the photos on site as you shoot them. Choose one with an optical zoom because it will mimic what you see with a film camera telephoto lens; a digital zoom simply enlarges the center of the photo and crops the outer edges. Photographs taken with a digital zoom do not have the same image quality as those taken with an optical zoom.

Using the LCD monitor on the back of the camera rather than the optical viewfinder enables you to compose your photograph and immediately see the results. You'll then be able to tinker with your photographic technique to capture the best shot.

Film or Memory Cards

If you are utilizing a 35 mm SLR, either black-and-white or color film can be used. Filters can be helpful when shooting black-and-white photographs. An orange filter increases the contrast, while a polarizing filter can reduce glare. Exposure times of 1/250th or 1/500th are suggested. Color film with an ASA of 200 shot at 1/250th of a second should yield a good result. Carry enough film to photograph stones from different angles and to try different techniques. It's the "just in case something goes wrong" film strategy that results in usable photos.

Purchase a large-capacity memory card for your digital camera so you don't run out of memory on your cemetery expedition. Having an extra card on hand is helpful when photographing large numbers of cemetery stones. Carry an extra set of batteries for either your film or digital camera.

Trip Essentials

In addition to your camera, film, and other photo-related accessories, you'll need to bring along a toolkit of helpful items such as

- a pair of gardening shears for trimming weeds and plants around the stone
- gardening gloves to protect your hands
- insect repellent to keep pests like ticks and mosquitoes away from you
- a spray bottle with water to help clean the stone
- soft-bristle brushes and a rag to wipe the stone
- something to kneel on, such as a gardening cushion
- an extra set of cloths or hand wipes to clean your hands after working around the stone
- a mirror for reflecting light onto the stone

Technique

Since you are creating a record of the cemetery in addition to photographing a single stone, you should take several snapshots of the same marker. Create a list of what you want. For example:

- A shot showing the whole cemetery
- A shot that includes the closest stones and provides context
- A photograph of the whole gravestone, with the inscription and carving visible
- At least one photo in which the inscription fills the camera frame

Unless you are extremely lucky, most of the stones you want to photograph will not be straight, due to ground settling. In the case of leaning stones, tilting the camera should eliminate the slant.

Regardless of whether you use a digital or a film camera, each photograph acts as a visual record of that stone, but it's helpful to have a paper backup. Remember to write down pertinent information from the stone in case something happens to your film in processing or to your digital file. It would be a shame to return home from a cemetery adventure to discover that the photos you thought would provide family history information are not usable.

Background

As you focus the camera, you may notice distracting background elements, such as other monuments, telephone poles, and trees. Since you want the focus to be essentially on the stones you are photographing, you need to eliminate those other elements. You can use a background cloth or cardboard as a backdrop, but make sure that whatever you use is free of imperfections, or

these will be more distracting than the original problems. If you are going to photograph a large number of cemetery monuments, you may want to invest in a piece of Formica mounted on quarter-inch plywood. Be sure to have a handhold cut into the side for easy carrying. Any store that manufactures kitchen counters should be able to provide what you need. A neutral shade other than gray enhances the appearance of the stone.

Other Ways to Improve the Quality of the Photograph

Cleaning the Stone

Cleaning a cemetery stone is a controversial topic. The first rule of conservation and preservation is to cause no damage. Unfortunately, by using household cleaners, chalk, and shaving cream to enhance the lettering, you may damage the surface in ways that are not readily apparent. Caution should be used before you destroy what you set out to preserve. Evaluate the stability of the stone before you attempt cleaning it. If the stone looks fragile, don't attempt it.

Over the centuries several different types of stone have been used to create gravestones. Some of the stones

are quite porous and fragile, while others are resistant to damage. Be careful when attempting to improve the readability of the inscription. Types of stone:

- Prior to the nineteenth century: sandstone or slate

- Nineteenth century: marble and gray granite

- Late nineteenth century to the present: polished granite or marble

There are a few things you *can* do that will not cause damage.

- A soft brush or natural sponge and water will help you remove surface soil. Gentle brushing should remove surface dirt and bird droppings. Power washing should not be used; water should flow over the stone or be delicately sprayed onto the surface. Never use hard objects or stiff brushes to clean the stone. Removing lichens with sharp objects may inadvertently destroy the surface.

- Not all cemeteries are regularly maintained. By trimming tall weeds around the base of the stone and cutting the grass, you may discover epitaphs hidden under the overgrowth.

Documentation

Local historians and genealogists have transcribed inscription information for generations. Many of these handwritten and typewritten efforts are now being entered into online databases like those listed in the "Cemeteries & Funeral Home" category on Cyndi's List <www.cyndislist.com>.

Photographs are an innovative way to create a record of both the inscription and the carvings. By using a pictorial representation of the headstone as part of your database, you're able to see what actually appears on the stone, including both the epitaph and the artistic carving. It is a record of what the cemetery marker looked like at a particular time before further damage occurs or the stone disappears.

If you live near or know about a cemetery in your area, why not assist with the preservation efforts by photographing each stone in it for future reference? A local historical society or cemetery association will appreciate your efforts. Be sure to check with them before embarking on the project so there is no duplication of effort.

Activity: Create a Family Memorial with Photographs

There is virtually no way to collect photographs of everyone on your family tree. Anyone who died before the beginning of photography in 1839 obviously never sat for a photographic portrait. However, that doesn't mean you can't include them in the family photo album. Keep their memories alive by taking photographs of their gravestones.

- First search death and burial records to see if you can identify the cemeteries where they are buried.

- Next, contact family members who reside in areas where relatives once lived. Ask them to photograph the stones.

- Place the photos in your family scrapbook, or attach digital files of the images to the record sheets in your genealogy software program.

- Consider submitting these photos to a national database of gravestone images, or create your own website with images of family headstones.

A basic record sheet on a cemetery photo should include the following:

- Location

- Map of the cemetery with the stones numbered

- Date and time photographed (and frame number)

- Transcription of the epitaph

Database software is available from the Association for Gravestone Studies and is being used for cemetery projects across the United States. If you want to learn more about photographing cemetery markers or are curious about the history of gravestone carving, you can contact the following organizations.

The Association for Gravestone Studies (AGS)

278 Main St., Suite 207, Greenfield, MA 01301
(413) 772-0836; <www.gravestonestudies.org>

The association sells a basic information kit through its gift shop and publishes an annual journal on gravestone history called *Markers*. Membership is open to all interested individuals. The AGS holds an annual conference with workshops, lectures, and tours. (For more information and registration forms, consult the website.) The society also maintains a lending library for members.

Connecticut Gravestone Network

<www.ctgravestones.com>

Founded in 1995, the network's mission is to educate individuals about the history and preservation of cemetery art. The website includes a list of dos and don'ts of gravestone documentation.

References

Carmack, Sharon DeBartolo. *Your Guide to Cemetery Research*. Cincinnati, OH: Betterway Books, 2002.

Cornish, Michael. *Photographing Gravestones*. Greenfield, MA: Association for Gravestone Studies, 1990.

Farber, Daniel, and Jessie Lie. *Making Photographic Records of Gravestones.* Greenfield, MA: Association for Gravestone Studies, 1986.

Walther, Tracy C. *Cleaning Masonry Burial Monuments.* Greenfield, MA: Association for Gravestone Studies, 1990.

Heirlooms, Documents, and Photographs

A large part of genealogical research is locating materials that add data and stories to your family history, such as documents, photographs, memorabilia, and artifacts.

When you visit a relative to gather some facts about the family, she might begin showing you boxes of photos, official papers, and even artifacts.

Photographs

Say Great-aunt Sue owns a large group of family papers and several containers of photographs, as well as paper memorabilia. She also tells you about family material donated to the local historical society.

As you know, there are multiple ways to copy two-dimensional documents and photographs. You can photocopy them, scan them, or photograph them using a copy stand or tripod.

Photographs can also be copied using self-service photographic kiosks located in many stores and camera outlets. That's a good solution, except relatives might not allow you to borrow the original photographs, and it's almost certain that archives won't let their collections leave the facility. Another option is to purchase a lightweight scanner with a full-size bed that's portable and small enough to put in a rolling suitcase. However, you'll also need a laptop to attach to the scanner. For more information on copy stands, tripods, and portable photo studios see pages 71–72.

Heirlooms

During your visit with Great-aunt Sue, she gives you a tour of her house. Hanging on the wall of the living room is a painting of your great-great-grandfather, and underneath it is his favorite chair. Both of these objects, like other three-dimensional artifacts, can't be scanned, photocopied, or copied using a self-service kiosk. These items range from small pieces of jewelry to full-size

furnishings. An heirloom that's been in the family for several generations, or the one that's become special because it was a gift from a friend or family member, is just as important genealogically as a resource.

A simple solution to both of these scenarios is to photograph (with permission) those items. It's a cheap alternative (especially if you own a digital camera), and you have copies you can use later in your family history. Photographing all of this material requires a little preparation and a lot of practice. Try it at home first to get comfortable with the procedures.

Preparing for the Trip

Packing for a picture-taking research trip requires more than a pencil and paper. There are components that enhance your ability to take photographs of both the two- and three-dimensional items you encounter. Photographers travel prepared for a variety of shooting opportunities, and you should as well. A visit to a relative's house for a family dinner may turn into a genealogical gold mine of family material. An opportunity to capture that information may not present itself again. Keep a separate bag packed with some photographic basics so you can quickly preserve the information.

Basic Requirements

No family research trip should be undertaken without a camera bag loaded with extra film (or memory cards) and batteries. There are other essentials for photographing objects that will quickly become part of your family history photo package.

Camera

Regardless of whether you use a film or digital camera, you'll need a macro zoom lens or a set of closeup lenses. For clarity, a digital camera with an optical zoom is better than a digital zoom. (See "Lenses" on page 134 for additional details.) Purchase a cable release to take pictures without placing your finger on the shutter and causing inadvertent movement. If looking through your camera's standard viewfinder is uncomfortable while looking down at the item being copied, consider investing in a different type of viewfinder that attaches to your camera but allows a normal viewing angle in spite of the camera's placement.

Copy Stand

You can purchase a professional-quality copy stand, but they are expensive and aren't usually portable. Instead, you can create your own. A copy stand consists of lights, a platform, and a pole in the center on which a camera can be mounted. You need to be able to move the camera up and down the column to change the magnification while keeping it parallel to the flat document or photo you are photographing. A small level can verify that your camera is parallel. John Hedgecoe, in *The New Manual of Photography* (DK Adult, 2003), illustrates a homemade copy stand using two desk lamps, a flat surface, and a tripod that allows the camera to point down. Key design elements are that the camera is perpendicular to the center of the platform and that the camera and flat surface are parallel. If they aren't, then part of your photograph will be out of focus. A fully adjustable tripod lets you change your distance from the item being photographed. Different sized tripods will also work. Use online search engines to find specific plans for building a more sophisticated model, or purchase a "portable" model at a camera shop.

Lights

If you build a copy stand, you'll probably want to use tungsten bulbs rated at 3200 K, a reference to the color temperature of the light. Two lamps evenly spaced create

balanced light. Both lights should be the same type and wattage. Check for shadows, and make adjustments as needed. Daylight is also an option. Bright, cloudy days diffuse sunlight. On sunny, cloudless days there are lots of shadows. Check readings on your camera's built-in light meter to set exposure and shutter speed. If you don't have a built-in light meter, consider purchasing a handheld version. Less expensive digital cameras have automatic settings. Use the correct film for the lighting. In my experience with tungsten bulbs, one should use

tungsten film, or you end up with discolored images due to the light. I strongly suggest using tungsten film to eliminate color variations.

When lighting a three-dimensional object, try using a single light from different angles to see which creates the most visible detail. You can also produce a soft, reflected light by directing the light at a sheet of white paper and bouncing the light off the paper and onto the object.

Portable Photo Studio

There's a great solution for photographing small objects and cased photographs. It's a portable photo studio. The best part is the price: It sells for less than a hundred dollars. Each foldable kit comes with two tungsten lamps and a nylon mesh box "studio" with a backdrop. The whole thing folds for portability. It's easier to lug around than a homemade copy stand.

Accessories

As you become an experienced photographer, there are other accessories to consider adding to your camera bag. These items are not necessities, but learning to use them will enhance your ability to photograph in difficult situations.

Filters

Filters come in different colors or models and attach to the camera lens. They can improve the final appearance of what you're photographing if you know what you're doing. Polarizing filters eliminate reflection, while others are used for special effects. Here are two types commonly used in closeup photography.

Colored filters enhance complementary colors and lighten the appearance of any similar colors. For example, if you were to use a red filter to take a black-and-white photograph of a page covered in red handwriting, it wouldn't work, but if you used a green filter, the contrast would increase and the writing would be legible. A simple color wheel can help you decide which colored filters work in different situations.

There are three primary colors: red, yellow, and blue; and three secondary colors: green, purple, and orange; made from mixing the primary ones together. Also on the wheel are so-called intermediate colors made from mixing one primary with a secondary color. If you are trying to increase the contrast between the background and the color, take another look at a color wheel. Colors on opposite sides are complementary, such as red/green, blue/orange, and yellow/purple.

The Necessities

- Camera
- Cable release
- Tripod (tabletop and one larger)
- Macro lenses or closeup lenses (or a digital camera with an optical zoom)
- A small level
- Lights—tungsten (3200 K) or daylight
- Notebook and writing instrument
- Portable photo studio

Light-balancing filters change the color quality present in each photograph, depending on light. For example, a photo with yellowish tones due to overhead lighting can look more normal by using a yellow filter to eliminate the yellowish cast.

Background

Choose a background that highlights detail and adds richness to your photographs. Silver is usually photographed on velvet; the softness of the fabric enhances

73

the qualities of the metal. You can choose a simple colored fabric or paper. I find that black works best for most situations unless I'm trying to

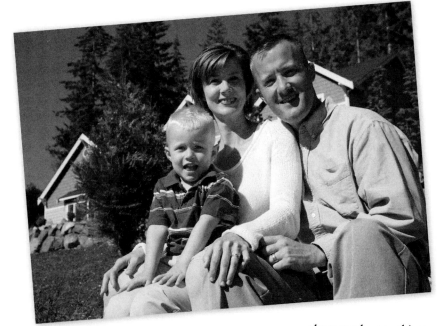

photograph an object like a tintype, which is almost black. A lighter colored background is a better choice in those instances.

Some photographers use a magnetic copy board with markings to ensure that the flat object they are photographing is straight. Large magnets hold the edges of an item in place, creating a frame around the item. They will also keep a paper document flat. Never use any type of adhesive to hold an item in place or damage an artifact with push pins or staples. Do your best to obtain a clear, focused photograph without damaging the original. Magnetic copy boards can be purchased in camera stores.

Getting Ready

The materials we locate in our family history research are not usually in pristine condition. Depending on how and where the items have been stored, you'll find a variety of debris attached to the surface, from dirt to decomposing rubber bands. Gently brush the surface of an object using a soft camel hair brush with an air syringe attached. These inexpensive items are available in photo stores. If the item is stained or has debris stuck to the surface, don't try to clean it. You could damage the original. Here is a list of basic rules to follow:

- An original is a valuable family artifact and should be treated gently.

- Wear white cotton gloves when handling artifacts.

- Any object that is flaking shouldn't be brushed.

- Never remove daguerreotypes (shiny, reflective metal photographs) or ambrotypes (photographs on glass) from their original cases.

- Don't use cleaning supplies on any artifact unless approved by conservators. See tips on the American Institute for the Conservation of Historic and Artistic Works website <aic.standford.edu>, or consult one of the books in the reference section.

References

Long, Jane S., and Richard W. Long. *Caring for Your Family Treasures.* New York: Abrams, 2000.

Mailand, Harold F. *Considerations for the Care of Textiles and Costumes: A Handbook for the Non-Specialist.* Indianapolis: Indianapolis Museum of Art, 1980.

Schultz, Arthur W., ed. *Caring for Your Collections.* New York: National Institute for the Conservation of Cultural Property/Abrams, 1992.

Conservation Help

American Institute for Conservation of Historic and Artistic Work, Inc. (AIC)

Conservation Services Referral System
1717 K Street, NW, Suite 200
Washington, D.C. 20006
(202) 452-9545
E-mail: infoaic@aol.com
Website: <aic.stanford.edu>

Documentation

Taking notes on the item you're photographing is documentation necessary for later use of the object. It doesn't matter if you use a notepad, PDA, or laptop, but have a way to record the name and contact information of the owner, plus the history of ownership (known in museum terminology as the provenance) as well as a condition report. You might need to contact the owner later about an additional detail you've discovered while doing genealogical research. Attach your photograph to the worksheet you've created on the object.

Tips for Special Situations

General

- Use a plain background.

- Don't use the flash unit that is part of your camera. Use an external flash or lighting whenever possible.

- Take several different shots of the same item at a variety of settings.

- Practice your technique at home before you need to try it in a new environment.

Photographs

- Photograph pictures flat so that the entire image is in focus.

- Photograph daguerreotypes at an angle so that the image is visible.

- To avoid reflections when photographing items under glass, follow photographer and author John Hedgecoe's suggestion and place a piece of black cardboard around the camera lens or two lights evenly spaced from the object rather than using a flash.

Three-dimensional Objects

- Light the object from the side to increase contrast within the detail.

- Utilize colors and textures to enhance the appearance of an artifact.

- Control reflections using the same suggestions listed above for items under glass.

References

Copying and Duplicating: Photographic and Digital Imaging Techniques. Rochester, NY: Silver Pixel Press, 1996.

Photographing Microfilm

Juliana Smith, editor of the *Ancestry Weekly News*, wrote about her first experiences using her digital camera for research in "My First Digital Research Trip" (*Ancestry Daily News* 20 September 2004), and this was followed by a reader's formula for success in a "Quick Tip" (23 September 2004). Together, these two individuals found a way to save time and money using a digital camera. Rather than spending time transcribing information from endless frames of microfilm, use their time-saving tips, which are summarized below.

Equipment

When photographing microfilm, use a camera with a clip that attaches the camera to the microfilm reader. The clamp stabilizes the camera, but I'd also use a cable release to prevent any movement. The clip holds the camera in place and eliminates constant refocusing.

Since most microfilm machines have a shiny surface, cut the glare with a nonglossy piece of white paper or cardboard. If you need to enhance the microfilm image, try using a colored filter on your camera or experimenting with different settings available with your digital camera. You'll be able to edit the photographs later with photo-editing software.

Documentation

Relying completely on your photographic expertise when photographing microfilm for the first time can be a mistake. You might return home to find your photos aren't usable. Juliana Smith uses a spreadsheet to record basic information on each photograph such as photo number, surname, given name or head of household, as well as record descriptions and year. You can also record the call number and repository or the Family History Library film number for each frame. This later serves as both a research log and a checklist of photographs.

Technique Tips

- Save time transcribing citation information by photographing the title page.

- Use Post-it notes to include citation information in the picture and prevent mix-ups. (But don't stick the Post-it to the image because of the adhesive.)

- Keep a notebook of frame numbers and citations as a backup—just in case.

As you experiment with photographing family papers, heirlooms, and gravestones, you'll discover other ways to photographically document your heritage. Your research experiences will encourage you to seek creative photographic solutions to take home evidence of your trip or visit to a relative's house.

Activity: Make a Family Scrapbook

Documenting your family doesn't have to be just photographs with short captions. Scrapbooking gives genealogists a way to express their creativity with artifacts, embellishments, and images. You can explore this popular hobby by looking at magazines like *Creating Keepsakes* and *Memory Makers*, by checking out books published on various types of scrapbooks, or by going online to look at layouts, such as those featured on Two Peas in a Bucket <www.two peasinabucket.com>. Scrapbooks can be handcrafted, produced entirely on a computer using photo-editing software, or a combination of both.

Start by selecting a theme. It could be a person, a day, an event, or a family tree. Decide if you're going to create a single page or a whole album. Beginners should limit themselves to a page to try out this activity.

Then choose a format. Sheets of paper and albums are available in a variety of sizes.

Next, combine colorful backgrounds, stickers, and your photographs for a unique family history artifact. Novice scrapbookers might want to invest in a kit that comes complete with everything they'll need to create a few pages. Select products made of acid- and lignin-free materials and non-PVC plastic so your great-grandchildren will still be able to enjoy your efforts.

Include photographs of people, documents, artifacts, and gravestones related to the family or person represented in the scrapbook.

References

Campbell-Slan, Joanna. *Scrapbook Storytelling*. Cincinnati, OH: Betterway Books, 1999.

Langford, Martha. *Suspended Conversations: The Afterlife of Memory in Photographic Albums*. Montreal: McGill-Queen's University Press, 2001.

Ledoux, Denis. *The Photo Scribe: A Writing Guide: How to Write the Stories behind Your Photographs*. Lisbon Falls, ME: Soleil Press, 1998.

Taylor, Maureen A. *Scrapbooking Your Family History*. Cincinnati, OH: Betterway Books, 2003.

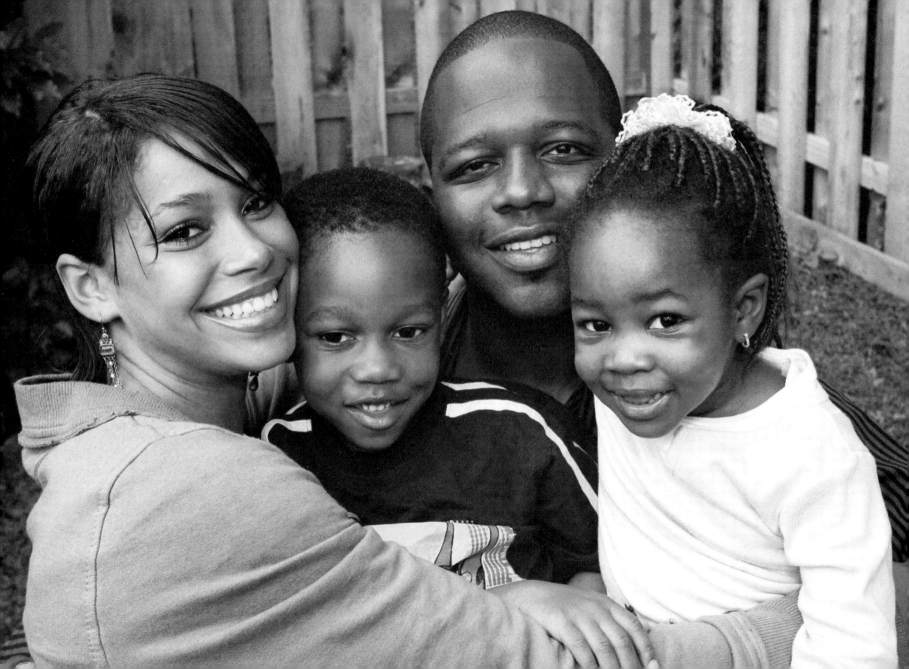

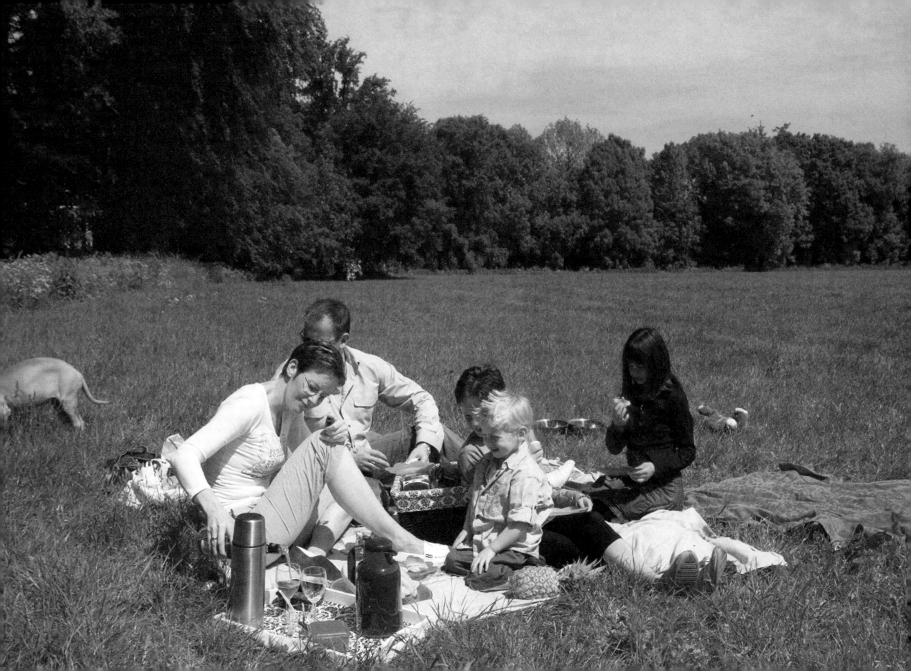

⊕ Get the Whole Family Involved

DON'T BE THE LONE PHOTOGRAPHER shooting pictures for the whole family. Recruit other relatives to help. Everyone from school-age children to seniors can join the fun, including those cranky teenagers who are always complaining they are bored. Stick a camera in the hands of restless teens with freedom to shoot what they want (within reason), make photo-editing software available to them, and let them create. Give gift cameras to older relatives, show them how to use them, and ask them to take pictures of the people that matter most to them.

Each person approaches photography differently. My son gets close to his subjects, while my daughter likes to stand back from the action. Our family albums feature pictures taken by all of us, using a variety of cameras. Thus, no two pictures of the same thing are exactly alike. The wide range of perspectives and subjects makes for a more interesting arrangement of vacation photographs. Now put a camera into the hands of everyone at a family event and see what happens. You'll be surprised at the results.

So what are you going to do with all these photographs of family events, special occasions, reunions, and genealogical research documents? Please don't say you're going to put them in an album and store them

obtain a CD-ROM copy of their photos through a third-party service. Make copies of your photographs and save them to a CD-ROM or external hard drive to preserve them. It's also a good idea to make prints of any significant photos. Although currently less than 40 percent of consumers make prints of their photography, there is no reason not to do so. Photo printers are relatively inexpensive, and the cost per print is dropping.

Don't let these issues discourage you from exploring photo-sharing options using the Web. These sites are easy to use, offer photo-editing tools, and provide some new ways to show off your photographs of relatives and family events.

Questions to Consider

Is the site an online photo processor or strictly a photo-sharing site?
The line between them is a little blurry, but the services offered by both can vary significantly. Be sure to read through all the conditions and site documentation before signing up.

How long has the company been in business?
Four years ago, I wrote about several of the top-rated

photo-sharing sites. Of the twelve I mentioned, only four are still in business. You can research the company by using library information databases that index newspapers, magazines, and business databases. You can also type the company name into an online search engine to find the latest news and developments.

What happens to your electronic files if the company ceases to exist?
If the company ceases operations quickly, it might not notify its subscribers. Always back up your photo files at home instead of relying on a third party for preservation.

What photo-editing tools are offered?
All these sites offer some photo-editing tools, but if you want to make sophisticated changes, invest in photo-editing software and do it at home. You can always upload the photographs later once you've made improvements.

Are your photographs password protected?
I can't restate this too many times. Find a reputable site with private albums and passwords or one that you

have to invite people to view. It's incredibly easy to copy and reuse digital images once they are posted publicly.

Are you limited on the number of files? Can you purchase more space?

Free sites usually provide a limited amount of storage for your electronic files but offer ways to expand that by charging fees based on the amount of storage you'll need.

Is there a maximum size at which you can display or print?

Images are usually resized for the Web to cut down on storage. You might be limited to viewing photographs at the reduced resolution of 72 dpi or be able to view them at a higher resolution if you want or need to. This becomes particularly important if you're trying to see the detail in a digital image of an old document or identify a part of an old photograph.

How are vertical images handled?

Take a look at the sample albums available on most sites to see how they handle different sized images as well as verticals. You'll want to be able to view all of your photographs with ease.

How do you upload your photos?

When you send your photographs to an online photo processor, they are usually automatically posted online to make it easy to order extra prints. Most photo-sharing sites ask you to download software to be able to upload (i.e., add) photos to your account.

Sites to Try

Enter "photo sharing sites" into an online search engine to find a site to try, to read reviews, or to discover the latest news about the topic. Basic features include editing, uploading software, and merchandise. Some offer friends and family a way to add messages to specific photos or albums. In the spirit of competition, each one offers something a little different to entice you to be a customer. Photo-processing sites often combine processing with sharing opportunities.

Winkflash.com

You can use Winkflash to turn your digital photos into prints, books, posters, high-resolution downloads, and more. Or edit, organize, store, and share your photos online.

Webshots.com

Store your photos in public or private albums, access information on new photography products, use the online gallery of professional photographs, or order personalized gift items.

Snapfish.com

Order prints, share your images, or make personalized gifts on this simple-to-use and very popular site.

Kodak Gallery.com <www.kodakgallery.com>

Order Kodak-processed prints, store your photos online, and order photo products and books in a wide variety of designs.

PhotoWorks.com

Edit photos and order gifts, photo books, and more. Your friends and family receive a link to look at an album instead of a large attachment that will clog their inbox.

Photo Projects Anyone Can Do

Tired of putting your photos in albums or letting them languish on your computer? Photo craft ideas appear on many camera manufacturer websites, and bookstores and craft shops carry titles on the topic. Try entering "photo crafts" in a search engine, and see what turns up. Warning: Many of these photo crafts are not intended to be preserved for generations. If you want to create a

preservation-quality project, use only materials marked acid and lignin free, and use markers and pens that are safe for photographs.

Activity: Create a Photo Bulletin Board

Let your photographs tell a story on a bulletin board or wall of your house. Think of it as a scrapbook page on the wall. You can even make it interactive by including a white board or paper for comments. Change the layout as rarely or as often as you want. Themes can be holidays, birthdays, random memories, or specific members of the family. Put someone in the family in charge of changing the scene. The whole project takes a minimal investment of time, money, and equipment.

Supplies

- Duplicate photographs (no originals)
- Bulletin board
- Covering for the board (paper, fabric, or felt)
- Stickers
- Embellishments
- Lettering

- A blank page for comments
- Adhesive, such as Aleene's Spritz-on Repositioning Tacky Glue

Step One

Select a theme and duplicate photographs to lay out on your bulletin board. You don't want to use originals because you'll be cutting the photos. Keep any layout simple rather than cluttered. You're making a collage, but not one that overwhelms with too many images. A person viewing the scene should be able to look at each photograph individually.

Step Two

Purchase your supplies. These can be inexpensive items you have around the house or some bought during a visit to a scrapbook supply store. Supply stores also carry a wide array of decorative elements to add to your scene.

Step Three

Assemble everything in one place. Try different layouts before you cut and paste. Cover your bulletin board using paper, fabric, or felt. Play with different methods

of covering the surface. You don't want to permanently affix the background, but you don't want it to come off too easily either. Incorporate embellishments as well as photographs to tell a story.

Step Four

Step back and enjoy your creation. Then it's time to start planning for your next scene.

Activity: Display Your Photos

Once upon a time, taking a photograph to be framed meant subjecting it to damage. Photos were set against the glass with a wood or cardboard backing and then placed in a wooden frame. The wood left behind stains from the lignin and acid inherent in the material, and photos placed in direct contact with glass often ended up sticking to it because of condensation. All of this damage can easily be avoided. The next time you decide to frame your photographs, take them to a reputable framing studio that is trained in museum-quality framing. Look for someone who can supply you with acid- and lignin-free mat board, who understands that there should be space between the photo and the glass, and who can obtain baked enamel metal frames.

If you are producing your own prints, do so using one of the more stable photographic processes tested for "display permanence" and recommended by Henry Wilhelm on his company website <www.wilhelm-research.com>. All other photographs should be copied prior to framing to protect the condition of the original. Copies can be made by producing a new print from a negative, scanning and printing another copy, or by using a self-service kiosk available in a variety of locations.

Framing is a set of separate layers. First, there is the photograph, followed by the acid- and lignin-free mat with a cutout for the photo. Then the photograph is backed with a piece of acid- and lignin-free cardboard. Finally, the multiple layers are placed in a frame, preferably using UV-filtered glass. If UV-filtered glass is not available, your copied photograph will be affected by sunlight-induced fading. Photographs printed using Wilhelm's processing suggestions resist fading under display conditions.

There are other ways to display your photos. Digital picture frames are becoming popular, as are media computers. With an Internet connection or home computer network, you can display your digital files using your

television, a media player, an oversized digital frame, or a slide show from a photo-sharing site. This technology is still evolving, but it is increasingly available to average consumers for a reasonable price. Reading reviews of new products before purchasing them is a good way to stay current with changing methods of picture display.

Activity: Express Yourself with a Family Website

Publishing a family genealogy in book form is not the only way to make your photographs and genealogical information available publicly. Many people are skipping the printing process and posting data online. There are many options. You can purchase your own unique domain name using an online registration service like Network Solutions <www.networksolutions.com> and post your family website, or you can use a service like MyFamily.com <www.myfamily.com> that hosts your site for a minimal fee. If you register your own domain, you are responsible for all site design and maintenance. With a family website service, you generally need only upload content; the site takes care of the rest. A third option is registering with a site like RootsWeb <www.

rootsweb.com>, where you can get free Web hosting for family history websites and projects.

Designing a family Web page yourself is relatively easy to do with templates available on Internet sites like Tripod <www.tripod.com>. If you want more sophisticated design options, purchase software like *Dreamweaver* and do it yourself from scratch. *Dreamweaver*

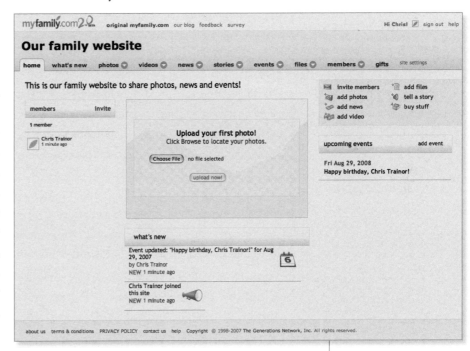

doesn't require users to learn a programming language like HTML, but it can be challenging for someone without a design background. You can also find free design help by using construction kits on popular sites like Cyndi's List <www.cyndislist.com>. If you're going to design a website, there are many issues to consider.

Why are you creating the site?
Think through your reasons for creating the site. Perhaps you want to share your genealogical knowledge or create a photo biography of your family. Before you decide what you're going to do, get ideas by looking at publicly posted sites. Search for them by typing a surname followed by the word *family* in quotation marks, and see what turns up. You'll discover some sites only for genealogy, while others brag about family exploits.

What information are you going to put on it?
Take a commonsense approach, especially with regard to living individuals. In this age of identity theft and image manipulation, it's best to follow some Internet rules to protect yourself and others.

- Select good-quality photos (in focus), and keep the content appropriate. What you think is funny may be embarrassing to the family member depicted. Make sure you have permission to post photographs of others online.

- Avoid placing any identifying information online, such as a person posed in front of the place where he or she works.

- With public sites, you need to be especially careful not to include too much identifying information that could be reused. In general, I prefer family sites with password protection and those that have a mailing list of invitees.

Will you be able to update the content?
The Web is full of outdated information and sites that seem to languish in cyberspace. If you're going to make a commitment to create a site, try to update the content regularly, even if it only contains genealogical data. Change the design or add information on a set schedule to encourage repeat visitors.

Is it public or private?
I'm always amazed by the number of people who post photos and information online for anyone to see. Don't

publish photographs of living individuals, especially children, and be aware of the less than scrupulous uses of public information on the Web.

Include the Basics

Remember to include a title, background, text, an e-mail address, and for visual interest, graphics. It's an online publication, so it should be user friendly and attractive. If there are too many sophisticated features that slow downloads, your viewers will have a tendency to click off.

References

Howells, Cyndi. *Planting Your Family Tree Online.* Nashville: Rutledge Hill Press, 2004.

Pring, Roger and Ivan Hissey. *Make Your Own Digital Photo Scrapbook.* New York: Friedman/Fairfax, 2002.

Activities for Family Reunion Fun

Family reunions provide the perfect opportunity to show off your research and photos. Carry a laptop with you for presenting what you've accumulated, a digital camera for taking new pictures, and some ideas for having fun with photographs. You can order plenty of

merchandise featuring family photographs from any of the photo-sharing or photo-processing sites, but think of other ways to incorporate photography into a reunion.

Famous Relatives

Identifying the attendees with their progenitors can be difficult unless you're extremely familiar with all the

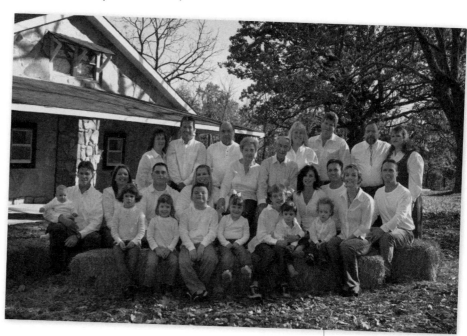

participants. If you aren't, provide t-shirts featuring a photo family tree for different branches of the family. Another way to do this is to create a life-sized cardboard cutout of a common ancestor and pose people next to it. Instead of posing with a president or a celebrity, you'll ask attendees to pose with their ancestors.

Scrapbook the Event

Let attendees create a scrapbook page for their family by supplying photographs and prepurchased kits. You'll have a lasting memory and can duplicate the whole project to share with family.

Add to Your Knowledge of Family History

Pack for a reunion like you would for a research trip. You'll be taking pictures and collecting stories, so bring along a camera to copy photographs, as well as a tape recorder. You never know what memories a photograph will trigger or what new genealogical data will surface at a family reunion, so be prepared.

Set Up a Copy Station

Ask attendees to bring copies of their family documents and photographs, and set up a photography station. You're sure to amass a lot of new material from relatives who've inherited family material. You'll be able to post their contributions online in your photo-sharing album or publish them on a private website.

Activity: Produce a Family Magazine or Newsletter

Put those creative members of your family to work on creating a family magazine or newsletter. All it takes is some word-processing software and a photo-editing or other design package (like Microsoft *Publisher*) to turn a boring update letter into a work of art. Add photographs, graphics, documents, and more to the design. Rather than just writing about your family history trip to an ancestral village, include a few photographs as well as design elements from local landmarks to present the full tale of your discoveries.

There are endless ways to present the photographs and the moving snapshots of your family. I've listed only a few. Software packages continue to evolve, providing more opportunities for genealogists to express their interests. The Web offers a way for families to communicate within moments and creates a network of individuals willing to work together on projects. All of these projects and suggestions have two things in common: family and photographs. Add a little creativity, and you've got a recipe for success.

A Family in Motion

IN MY CHILDHOOD, MAKING A home movie meant shooting scenes using a film camera. You couldn't view what you had shot until after the film came back from processing. Each new roll of film was an event. The screen was set up, the lights were dimmed, and the projector was turned on. The entire family gathered in the dark to watch your antics and to listen (if you were lucky enough to own a sound camera) to the accompanying dialogue. Editing meant splicing pieces of the film together using razor blades and film tape. While there are still some individuals who use film, the current moving picture marketplace is all about digital video.

Regardless of which moving image format you use, ultimately it's all about telling a story. Digital technology is changing so rapidly that just in the time I've spent researching this book there have been new products. Rather than focus specifically on all the current options (which will be obsolete by the time this book is published), this chapter will explore the basic concepts and concerns behind purchasing a digital video camera, as well as how to use moving images to create a movie about an event or moment in your family's history. You'll be able to transfer older formats to digital files as well as add stills and anything else you consider an important part of the story.

Home Movies—Then and Now

As you dig through boxes in your closet, you'll probably find an assortment of different film formats because your family upgraded to new technology over the years. Consumers could choose between a variety of films, cameras, and even projectors. You might even discover some old equipment for taking home movies. You'll probably find an assortment of black-and-white and color films, depending on the equipment your family used and when they filmed. Color film for 16 mm cameras was available as early as 1928.

Sound was another issue. Most home movies are silent. Families could send their films out to have title frames inserted, but talking movies were difficult to produce and costly until the development of video. While Bell & Howell introduced a film system for amateurs consisting of a camera, tape recorder, and projector in 1968, it wasn't until 1973 that the Kodak Ektasound camera made it easier to record sound and pictures. Kodak discontinued the system in 1979—about the same time video became affordable.

Video Home System (VHS) appeared in the late 1970s, changing how families shot moving images. A typical cassette held a half-inch tape that traveled from one side of the cassette to the other as footage was shot. The VHS format was originally developed by JVC and was introduced in 1976. Both Sony and Philips introduced competing formats, but the half-inch tape quickly became the standard for family photographers. Since there was no processing involved, you could view what you shot immediately by using the camera or a VCR to replay the tape. Editing required special editing VCR decks, and it was time consuming. It meant

copying and then re-recording over pieces of the original footage.

Today consumers have embraced the digital video revolution. Cameras are affordable, light to carry, and relatively easy to use. It's possible to shoot a story, edit it in the camera, or download it to your computer and edit it using software that streamlines that process. You can add music to your creation and share it with others by posting it online or recording it on a DVD.

Digital Video Cameras

Before you start shopping for a digital video (DV) camera, revisit the criteria you listed in chapter 1 when considering a still camera purchase. The big question is, What are you going to use it for? If you're reading this book, your answer is, "For capturing family moments." Unless you want to become a professional digital videographer, you won't need to buy a professional model camera. There are plenty of options that won't break your budget. Two years ago, I researched DV and knew what I wanted. Initially, the price was too high for my wallet, but by waiting a few months, I was able to purchase a comparable camera with additional features. Watch for price drops in sales circulars and on product websites.

Setting a realistic budget and exploring the options are key considerations when purchasing a digital video camera. Price range has a role in video quality but doesn't affect editing capabilities. At a certain price level, what you'll get is video quality that compares to broadcast television. Regardless of price, digital video offers the convenience of editing and sharing using software on your home computer. Most consumer-priced cameras fit in the palm of your hand, making them easy to hold and use. Digital files can be duplicated with no loss of quality, regardless of how many copies you make, and the sound quality—which is also digital—compares to music CDs. Here are the basics:

Digital Video Format

Most digital video cameras around the world use a small tape cassette for images, but some companies offer models that record on a DVD. Product reviews of the different options explore the technical issues relating to each type of recording device.

International Standards vs. U.S. Standards

In the United States, the National Television Standards Committee (NTSC) sets a standard for DV camera

recording—525 lines and 30 frames a second—while in England, the PAL standard is 625 lines and 25 frames a second. France uses the SECAM standard, which differs from the other two. What this means for the consumer is that recording and playback are not interchangeable. You can't expect to play a tape recorded with the NTSC standard on a television that uses another standard.

CCD

The CCD, or charged-couple device, is the camera's image sensor that measures light in every scene. Cameras have either one combined sensor or three. The number of sensors affects the price and improves the picture quality.

Computers

Do you have a newer computer or an older one? If you intend to transfer your video directly from your camera to your hard drive on a PC, you'll need to have a firewire connection (also known as a DV, IEEE1394, or i.Link) to download the footage. This special cable connects the camera and the computer using this connection. You can buy an add-on for older machines, but beware that older machines may not have the processing power to handle video editing.

Another issue is hard drive space. Video files use a lot of it. Check the space on your hard drive before adding these files to your computer. Most video editing programs require a minimum of 512 MB of RAM, but 1 GB is better. You should buy the maximum RAM you can afford.

Television

With most newer televisions, it is possible to connect your camera directly to the TV using the audio/video terminal on the camera and color matching the cables to the input jacks on the television. Picture quality will vary based on the resolution of the television and the type of CCD in the camera.

Extras Worth Having

- **Additional tapes.** Each cassette records about an hour's worth of scenes, so you'll want to carry additional tapes with you. They are relatively inexpensive, so instead of shooting over an old tape, save the original as your master for the family archive and use a new one each time. Don't forget to label each tape with its contents. If you're using a newer model camera that records on DVDs, carry extras with you.

- **Batteries.** Buy an additional pack because the rate at which you use power depends on the camera's features, such as an LCD monitor or an attached light unit.

- **External fill light.** Digital video cameras don't come with lights. You have to purchase them separately. Buy one that has an independent battery pack rather than one you have to operate off the camera's power pack.

- **Tripod.** This will keep the camera steady in low-light situations.

- **Camera bag.** This actually isn't an optional piece of equipment. You'll need one to carry around all the accessories for your camera and the DV camera itself. Protect your investment and keep equipment handy by storing it all together. Look for protective padding and pockets for organization.

Things to Consider

- Where is the microphone located? On the front of the camera or closer to the camera operator? Microphones on the front tend to capture dialog spoken by the people being photographed, while the latter

does a great job of recording all your comments. It might be worth investing in an external microphone, but make sure your camera has a port for it.

- How does the tape load? Can you access the tape without releasing your hold on the camera, or is your hand in the way? You don't necessarily want to stop the action happening in front of the camera while you change a cassette.

99

- Take care of your camera. Find out how to use it when the weather is inclement, cold, or hot. You may not be able to take it everywhere. See disadvantages in the chapter on digital cameras.

Reading the Specifications

Audio: Sound recording specification usually described as "bits."

Maximum CCD resolution: Usually referred to as megapixels, but the format doesn't really conform to that measurement. The larger the number, the sharper the image.

CCD size: CCDs record color, but the size of the CCD influences the recording ability of the chip.

LCD: Not all cameras have an LCD for viewing as you're filming. If having one is an important factor for purchase, try out the camera first to see if the size of the screen is right for you. Specs usually include whether or not it swivels for viewing by individuals other than the camera operator. Using the LCD depletes the battery faster than using the eyepiece.

Image stabilization: This helps you keep the image steady while filming with the camera in your hand.

Aperture: The aperture, or f-stop, controls the amount of light let into the camera. The higher the number, the smaller the opening and the less light.

Zoom: Look for cameras with both an optical and a digital zoom. Digital zooms focus on the center of the scene, while optical zooms take the whole scene without a loss of quality. Larger zooms provide more flexibility.

Hot shoe: Standard equipment for connecting an attachment, such as an external light, to the camera.

Still-picture mode: Just as digital still cameras have a movie mode, some DV models come with the ability to take stills. Since the two types of cameras capture images differently, video quality doesn't compare to the photographs taken with a still camera.

Infrared capability: The ability of the camera to shoot in low-light situations without an external light.

MPEG movie mode: Footage shot in this mode can be sent via e-mail or posted online. It's a video format that can be played on a variety of mediums. It is not high resolution.

Special effects: These allow you to manipulate the output while you're shooting it, and they include such features as black-and-white, sepia, mosaic, wave, color mask, and others.

Fade options: Special effects that allows you to gradually black out a scene as a transition point or to bring up a scene. There are a variety of options with most cameras.

Tell the Story

Your footage is a frame-by-frame story of your family history, but even it doesn't tell the whole tale. Today's technology makes it possible for you to edit footage on your computer, write movie notes, and include package highlights. Share them with family via a CD or DVD, through a photo/video-sharing website, or on a Web page. If possible, write down a few facts about the events depicted on each video and leave your descendants the background behind the scene.

There are so many ways to engage your audience's attention with moving images. Lighting, sound, and composition are the most important components. Start by thinking about what you want to film; then move into the planning phase. It never hurts to be organized

about what you'd like to shoot. Having a storyboard or list of must-have shots can make a difference when you're editing. Suppose you were shooting a wedding but forgot to include footage of the bride and groom's parents. Preparing for a family history interview with a list of equipment and questions should also include a checklist of images you want to take in stills and video. Since you may not have the opportunity to go back and reshoot, be prepared for the event by compiling notes to consult before you leave.

Helpful Books

Jones, Frederic H. *How to Do Everything with Digital Video.* Berkeley, CA: McGraw Hill, 2002.

Sadun, Erica. *Digital Video Essentials: Shoot, Transfer, Edit, Share.* San Francisco: Sybex Books, 2003.

Story, Derrick. *Digital Video Pocket Guide.* North Sebastopol, CA: O'Reilly, 2003.

Lighting

There is a direct relationship between light and picture clarity. Trying to shoot a movie in a darkened auditorium won't result in perfectly clear footage. The scene will look fuzzy or grainy, and even colors may look unnatural. Understand the capabilities of your camera to interpret light to improve your home movies.

Read your camera manual to learn about features that enable you to use it in low light. If your camera has the capacity to shoot in a "night mode," that means you'll be able to capture footage in low-light situations. However, it will affect the quality of your footage. In digital terms, a fuzzy picture due to low light is called *noise*. If there is insufficient light, then you will see noise.

All visible light, including sunlight and lightbulbs, contains different colors that can affect the color quality of your video. Fluorescent bulbs with a rating of 4,100 K give off a blue color, while those with a 3,000 K rating are orange/red. The "K" stands for Kelvin, a scientific measurement of temperature, and shouldn't be confused with wattage. What this means is that the lightbulbs in your house and those in an auditorium all present colors influencing how we see a scene. Color variations in footage can be avoided if your camera has automatic white balance (standard on all newer models) because it adjusts and neutralizes color changes.

In any low-light situation, it is a good idea to carry an auxiliary light with you. You can use a light attachment that fits on your camera or a handheld or tripod unit. Any light that attaches to the camera is a fill light, which means it works only in closeup situations. If you want to light up the whole area where you are shooting, you'll need free-standing lighting in addition to the camera's flash.

Professional photographers also use reflective lighting. This occurs when you direct existing indoor or outdoor lighting using a special piece of equipment, such as a reflector disc, to increase lighting in a

specific area. You can also reflect light using mirrors or shiny metal.

Composition

Lights. Camera. Action! Those three words are associated with movie making. You've learned about cameras and lighting. Action is what happens in front of the lens. Apply the photographic concepts presented in earlier chapters on improving your photography to plot out your home movie. Sure, there is a lot of spontaneous movement in front of the camera, but it's also possible to script and lay out some of your scenes. It's about composing your shots to make sure you catch everything and everyone in action. Think of each still photograph as a single frame of a series of moving images, and approach composition carefully to make each shot your best. Here's a common scenario. You're trying to capture your daughter's dance recital on camera. Composition is about standing at the right vantage point to get the best shot. Of course, you're not going to be able to stand in front of other parents or interfere in the production, but scope out the auditorium and try to find a spot to stand (or sit) that maximizes your view.

Long before the camera rolls, the director knows what is going to be shot on a particular day. Sketches of a movie plan, called storyboards, are useful tools. You can storyboard what you want to capture by writing or sketching a series of ideas on paper in chronological order, showing how your video will flow and logically present the topic. You don't have to get it all right when you're shooting because you'll be able to construct the final product with editing. In general, it's best to take a variety of shots, think about the mood you're trying to create, and have fun with the project.

Here are some thoughts on taking a variety of shots:

- Closeups add interest.

- Long shots (video taken at a distance) provide a background or setting for the film.

- Mid-shots, those taken in between, usually act as a bridge between the near and far and help introduce a person or event.

- Reverse shots are taken from behind the participant, so the viewer shares his perspective.

- Create a look and feel (drama, suspense, or comedy) by changing the point of view with camera angles, lighting, and sound.

Sound Considerations

All DV cameras come with a built-in microphone, but these have a tendency to pick up noise from the photographer and the camera itself. Newer models include improvements in this area. An external microphone that you can place in front of a person is an inexpensive add-on that will improve the sound quality of your footage. In cases where sound is a problem, use an accessory mic or a lapel mic. With these more precise

instruments, you'll be able to point the mic in the right direction and capture the sounds you want instead of a lot of random background sounds.

Labeling

Here's a good habit to adopt: labeling your cassettes as you put them in the camera. Use a permanent marker, and write the date and the occasion on the box label or on the DVD before you place it in the camera, or use a soft tip permanent marker specifically for use on CDs or DVDs to prevent data loss. Even if you intend to shoot a series of family events, put a start date on the label so you'll know when you began shooting. Each new segment should have a date as well. Professional filmmakers create a log sheet of their shooting, recording start and stop codes from the camera and what they shot and when. When you begin editing your footage, you'll have the information you need at your fingertips. If you can, provide a synopsis of the story on your storage container, just like those on the back of the videos and DVDs you rent and buy. Model your labels after those in stores to include a list of participants and identification data that gives full names and dates.

Editing Footage

Very few films don't benefit from editing. The best news about digital video is that endless copies can be made without a loss of image quality, and you can manipulate

the images as much as you want. If you don't like what you've done, eliminate it and start over. It's a forgiving medium. Cut a piece of film and it's permanent, but a digital edit can be made again and again until you get it right. Here are some digital video editing tips.

- Do you have enough hard drive space? Be sure to check before you transfer video to your computer. According to Derrick Story in the *Digital Video Pocket Guide* (O'Reilly, 2003), it takes 1 GB for every 4.5 minutes of footage.

- Is your hard drive fast enough? According to Lee Gomes in a *Wall Street Journal* article titled "Tips for the Video Editor" (November 15, 2004), you'll need a drive that spins at least 7,200 RPM for editing purposes. Processing speed is also important. Video editing takes disk space, speed, and power, so get as much as possible.

- Have you paid attention to the time code when recording? The time code is the unique information related to each frame and piece of audio that provides two-digit numbers for hours, minutes, seconds, and frames. It allows you to find exactly the footage you want, as long as you've recorded the numbers.

- Do you have a DVD drive? After spending lots of time editing frames on your computer, you'll want to save or share them by making a DVD.

- Check to be sure that your camera is connected to the computer via a firewire connection.

When you write a story, there is a beginning, middle, and end. The same concept applies to film and video. The editing process consists of choosing footage, editing the shots to get the exact segment you want, and then organizing the segments into a series. A final step is adding extras such as titles and special effects. The whole process creates a visual tale of an event or family member. The goal is to put together a series of images that follows a theme, is enjoyable to watch, and has smooth transitions. These benchmarks have remained the same throughout the technological changes in capturing moving images.

Video-editing software packages let you reorganize your film, but most also offer you a way to improve the quality of what you've shot. Just like still photo-editing software, with video-editing software you can can alter lighting and color, add special effects, and eliminate distractions from images.

Read online reviews for the top ten products at the Video Editing Software Report <www.video-editing-software-review.toptenreviews.com>. You'll also find a list of terminology to help you through the process and answers to commonly asked questions. Before buying a software package, research the options. Look for a product that's easy to use, works with your computer specifications, and provides product support and documentation. Users of portable devices (iPods and Sony PSPs) need to verify that the software choice works with their equipment. Apple's *iMovie* video-editing software comes standard on all new Macintosh computers. If you're a Mac user and don't have it on your machine, you can purchase it as part of the company's iLife suite of applications at <www.apple.com/ilife/imovie>. PC users can try *Movie Maker*, which comes with Windows or can be downloaded with XP's service pack two at <www.microsoft.com>.

Before you invest in an editing program, try the product first by downloading free trials when they are available. Here are a couple of the top-rated programs at the time this was written:

Adobe Premiere Elements ‹www.adobe.com›

Adobe sells a variety of editing software options, including this video-editing program with a two-step DVD production process that creates a menu and scene index. You'll be able to share your movies using a variety of mediums, including the Web and mobile phones.

Ulead ‹www.ulead.com›

Ulead offers lots of software choices for digital imaging, digital video editing, DVD authoring, and other image applications.

Pinnacle Systems ‹www.pinnaclesys.com›

Pinnacle produces digital video software for professional studios and the average consumer. The packages are called *Dazzle* and *Studio*. A series of questions on the company website helps consumers determine which product fits their level of technical expertise.

Rules to Follow

The video quality of today's cameras and the editing packages available to consumers make it possible for your home video to look professional, so begin to think

this way. Consider what you like and dislike in professionally produced movies and on television; then utilize or avoid similar techniques when shooting or editing your footage. Become your own critic. Here are some general rules to follow to make your footage a family box office smash rather than a bust.

- **Smooth transitions.** Jumpy footage is not enjoyable to watch, and you'll lose the interest of your audience.

- **Keep it simple.** Instead of employing every special effect available in the camera and in editing, show restraint. The same is true for adding titles. Keep them to a minimum.

- **Add sound for variety.** Dialog recorded during the event can be accented by adding extra sounds recorded later, such as church bells, train whistles, or even music. Just don't overpower your footage with unrelated noises and music that distract rather than impress your viewers.

Sharing Options

After all the time and effort you've put into creating a video, don't let it sit on a shelf. Utilize the tools on your computer and camera to share it with family and friends interested in the topic.

- Some DV model cameras allow you to transfer to VHS via a VCR to share with family members that don't have DVD players.

107

- Edit footage and make DVDs to give as gifts. Model your presentation after the DVDs of commercial movies that you purchase. You can create labels, liner notes, and booklets using some simple, inexpensive software. Check your local office supply store for these packages.

- Post your footage online on your personal website using *QuickTime Pro*. The software costs $30 and can be downloaded from Apple at <www.apple.com>. Search for a *QuickTime* download. It works on both Windows PCs and on Macintosh computers. Just follow the rules for ethical usage (see chapter 8) when posting videos to the Web. Another option is to use a password-protected site so you can invite family members to view films privately. Most video-editing programs now provide users with the tools to upload their productions online.

- Download your footage to a portable device and take it with you wherever you go.

- Preserve your efforts by creating a backup of the original footage along with the edited version. Either duplicate the cassette or download it to your computer. Just remember to back up that data as well. A computer crash could wipe out your entire family film archive.

Activity: Family History Video

Moving images open up new ways to document your family history. From snippets of everyday life that you'll laugh at decades later to techniques for creating a catalog of family artifacts, digital video or film is another valuable tool in a genealogist's kit. Start by considering how to capture your life today with these suggestions.

Daily Life

Record moments of everyday life. Include simple tasks, such as washing the dishes and feeding the pets. Instead of just talking about someone's kitchen or house addition, film the person or people in the area to provide setting and to capture it for family history reasons.

Travelogue

Intersperse video of the sites you see on your vacation with still shots of your family participating in the experience. Endless footage of tourist locations can end up like a travelogue instead of a family history event.

Occupational Documentaries

Ask permission to take photographs at work to capture footage for a biographical film.

Capture Spontaneous Moments

Does your family, especially the children, act out scenes from their favorite cartoons and sitcoms? Family members have been involved in dramatic play for generations with charades and plays. Think about filming the action to replay at the next family event.

Life Events

Births, marriages, graduations, and other happy occasions probably make up a good percentage of family films stored away, but did you ever use these films as crucial pieces of family history? A wedding film that pans the audience provides you with a guest list of friends and relatives.

Biographies

Interview a living relative in both a formal and informal setting. Oral history recordings, with sound and picture, allow viewers to see as well as hear reactions to questions and props used during an interview. Follow the rules for interviewing: Set up an appointment, prepare

Transferring VHS to Digital

There are several ways to convert VHS (analog recording) to digital:

- Buy an analog-to-digital converter. This equipment lets you convert from one format to another.

- Purchase a digitizing card for your computer and connect the VCR or video camera to your computer.

- Buy a digital video camera with analog input capability so you can play back old tapes but record them digitally using your new camera. However, there may be a loss of picture quality in copying with this method.

- Invest in software to help you transfer and edit your videos. There are several different packages on the market, such as Pinnacle's *DVD Maker Plus*.

- Find a conversion studio in your area that can do the work for you. Their staff will be able to transfer not only your old video footage but films as well.

- Consult a guide like *PC Magazine's Guide to Digital Video* by Jan Ozer (Wiley, 2003) for assistance.

a list of questions, and ask for permission to film. Set up the camera in a way that leaves your interviewee

less conscious of its location, and start the interview. If someone might be nervous for a formal appointment, try a conversation in another location to capture personality.

Family Archive

Take your video camera with you on research trips. In addition to still photos of documents, use a camcorder to capture audio of you reading a document aloud while filming footage of your surroundings. Ask permission first, though, because many archives won't allow photography. Video is great for capturing sound and background, but it generally doesn't create sharp enough images for publication or photo prints. Bring along a still camera for those shots.

Multimedia

Combine new footage, old films/videos, and still photos to create a multimedia presentation that will wow relatives at the next event. Use a multimedia program, such as a film-editing program or Microsoft *Power-Point,* to portray the history of your family. Download your video to your iPod, and project the footage at your next family reunion.

Video within a Family History

Think you can't use film/video in your family history? Think again. Several genealogy software programs, including *Family Tree Maker*, let you import a variety of multimedia formats into your data.

Website Clips

Create a family Web page and investigate ways to use those edited clips. Find out how to embed video in a Web page using *QuickTime* or video-editing software. Whatever you do, just follow the rules for Web pages suggested by the National Genealogical Society at <www.ngsgenealogy.org>, and don't use any videos without the permission of the person in the clips. There are sites that allow you to share video online, either password protected or for public viewing. Similar to a photo-sharing site, you can upload your digital video to the site and invite your family to see it live.

Transfer Old Formats to Digital

One of the most common questions regarding digital video recording and playback is what to do with older format motion picture and video family films. Changing technology affects the way you can view and use

Preserve Past Formats
(Adapted and updated from "Reel Treasures" in *Family Tree Magazine*, **June 2002)**

I've heard amazing stories of individuals discarding film-recorded treasures once they've transferred them to VHS or DVD because they lack the equipment to project them in their original format. Don't be tempted to do the same. The film itself is an artifact, and a copy is not necessarily as good as the original.

Film Care

Before you start digging out the old projector, there are a few things you need to know about film preservation. The movies in your possession may not be in good shape, and playing them can break the film, or a faulty projector can destroy the image. Instead of projecting the original film and risk damaging it, have an expert make a DVD copy for viewing. Film shrinks and becomes brittle over time and will need treatment before it can be projected. Color film fades or shifts as it ages. Avoid handling the film, but if you must, touch only the edges, just like with photographs. Examine the film for signs of deterioration, such as cracks, tears, or brittleness. Before you lose the images, copy the original film onto another format and store it at a stable temperature and humidity. (See a list of album suppliers in the appendix). A professional film conservator can help stop the deterioration of any particularly important films. Do not dispose of the original, because videos and DVDs are not as stable as film.

Safe Storage

Thank goodness it's easy to keep your film footage safe for the future. All it takes is a cool, dry place. Film conservators suggest an environment with less than 50 percent humidity, but you'll be able to slow deterioration just by storing the film flat in metal cans or plastic boxes in an area with a stable temperature and humidity. The worst places to store any of your family history items are attics, basements, and garages. Pests, mold, and temperature or humidity fluctuations can rapidly damage any item kept there in less than a decade. The Library of Congress website ‹www.loc.gov› has more useful tips for caring for film.

Video

Videotape is a type of magnetic tape that records images on metal oxide-coated polyester tape. A VCR plays the tape, but each time you do, it wears away at the metal oxides and degrades the images. Dirt adds to the problem. There are several types of damage to look for: blocking (where tape sticks together), dropout (missing magnetic material), and deterioration of the

base. Remember that videotape is a temporary storage medium; most tapes are unplayable in under a decade. The cheaper the tape, the less likely it is to last that long. Your only solution is to make a preservation copy of the tape and store it away from magnetic sources. The Clarke Library ‹clarke.cmich.edu› at the University of Michigan suggests buying brand-name tape, checking it once a year for damage, rewinding your preservation copy, and making sure you regularly clean the VCR.

CDs/DVDs

While more stable than video, the longevity of CDs and DVDs has not been clearly established. Initially, CDs lasted only about the same amount of time as videos, but manufacturers report that their products now should last fifty years, and they are working on disks that will last even longer. Of course, who knows if the equipment will exist to play back the medium by then? Light, heat, and abrasion damage these discs. Just like film and photographs, it is best to handle them by their edges and store them in a cool and dry environment.

these out-of-date formats. Film can always be viewed, scanned, or printed from because it doesn't need special equipment to see what's on it. While film images are usually projected, you can also see what's on a roll of film just by holding it up to a light. Video is a different matter. You can't view a video without using a VCR or your camera's playback feature. What you can do is convert film and video to a digital format to make it easy to edit and share. Keep the originals as archive copies, and follow the preservation recommendations below.

Film Conversion

You've probably discovered that your home movies have rough transitions and extra footage. You'll want to edit them to eliminate blurry images and blank footage, but not at the expense of the film. You have a choice: You can edit them before transferring them to video by cutting and splicing the footage, or you can wait until after you have the copy and edit in that format. One is more expensive than the other, but I wouldn't want to risk damaging the original film in the editing process. The good news is that there is technology to help you create a new movie you can share with others either on video,

CD, DVD, or online. With technology improving the process all the time, it promises to get even easier.

Resources

Advice on making great home movies is available from product and camera manufacturers. Use the name of the company or product as a search term to locate the appropriate website. You'll find tips, news items, and alerts on product updates.

PHOTOGRAPHY FORBIDDEN IN THIS AREA

Ethical Considerations

TAKING FAMILY PHOTOGRAPHS IS about more than clicking the shutter. Professional photographers follow a set of ethics and laws governing their work, and so should the average family photographer. These business practices are good rules that you can apply to your family photographs, whether you've taken pictures of people or shot family memorabilia. Ignorance of the law doesn't mean you can't be found in violation of it. Follow these simple rules, and you won't go astray.

Ethics and Family Photographs

Ethics and law can be two separate things. One is a model of behavior that is acceptable; the other is special legislation overseen by the government—for example, copyright. Family photographers concerned with creating a website or publishing a genealogy need to be aware of both good photographic manners and the law.

Photo Etiquette

No Photography, Please

If you see a sign that says "no photographs" or "no flash photography," *don't* take a picture. These signs are often visible in private museums and archives. Most have rules regarding photographing the collections. If you don't see a sign, inquire about the policy.

Ask First

Before you start taking pictures of relatives, ask if it's okay. They may object to being photographed. If they say no, then no it is. Don't proceed without their permission. If you intend to use their photographs in a publication—online or print—obtain a release form to protect you later on. The book *ASMP Professional Business Practices in Photography* (Allworth Press, 1997) contains sample release forms covering adults, children, and property.

Don't Post Online or Publish without Consent

The same applies to family photographs you decide to publish in a book or online. Never post someone's photographs online without prior consent. (See also pages 84–85 for the pros and cons of posting photos on a publicly accessible site.)

Offer Copies

After making a trip to someone's house for a visit, it's usually customary to say thank you. Add a nice personal touch to your message by sending along one of the photographs taken during your visit. Invite the relatives (provided they have a computer) to see all the photos on a password-protected photo-sharing site, or send them duplicates. The next time you need to visit, your generosity will be remembered.

Copyright

According to the *Oxford American Dictionary* (Oxford University Press, 2001), copyright is "the exclusive legal right, given to an originator or an assignee for a fixed number of years, to print, publish, perform, film, or record literary, artistic, or musical material, and to authorize others to do the same." Whole books are written on copyright alone. It's a complicated concept. Your photographs are automatically protected by copyright once they are created, whether or not you include a copyright notice on the picture or register the copyright. While it's unlikely that you'll want to register the copyright on any of your family photographs, there are things you need to know about copyright before reproducing images of objects, documents, or photographs on your Web page or in your family history.

Using photographs and other images is a complicated issue. There are public domain images you can use for free, but for other photographs, the owner of the copyright will charge you a royalty fee to use them. So

116

when is a photograph in the public domain? It depends on several factors, including whether the photograph is unique, if it has been published, and the creation date. Keep in mind that a photograph does not require a copyright symbol to be protected under the law.

According to copyright law, a photographer is considered the "author" or creator of photographic works and thus is the legal copyright holder. If you want to make photographic copies of a photograph, alter it, or publish it, you might need the photographer's permission to do so. Or the photographer may have transferred the rights to another individual or institution. You need to proceed carefully when using old images and other illustrations rather than assuming they are in the public domain.

Copyright also applies to materials produced in other countries, but terms vary depending on whether the country of origin participates in international copyright agreements.

What Is Copyright Protected?

- Maps, charts, photographs, artwork, and written materials are covered by copyright, as are architectural drawings and songs.

- Unpublished materials, such as diaries, letters, and other manuscripts, are also protected.

- In order to reproduce any of these materials, you'll need to obtain permission first.

What Is Not Covered by Copyright?

There are materials that are not protected by copyright. A full list of conditions appears on the United States Copyright Office's website <www.copyright.gov>. In general, the following can't be copyrighted:

- Ideas

- Titles or names

- Slogans

- Facts

- Government-issued documents, such as census records and birth certificates; it is illegal to reproduce money, passports, and naturalization papers

Public Domain

Other materials are considered to be in the public domain. This means they are no longer protected by copyright and are free to use. Consult the "New Rules for Using Public Domain Materials" at <www.copyright.cornell.edu/public_domain> for full details.

- Unpublished materials such as diaries, letters, and other manuscripts are covered by copyright for the life of the author plus seventy years. This includes the family papers in your attic. If the person died before 1937, then his or her materials are in the public domain. If the death came after that point, wait until seventy years after the death for the copyright term to run out, or ask heirs (children or grandchildren) for permission.

- If you are unsure of a death date, or if the documents were created anonymously or by a corporation, the item may be covered by copyright protections for up to 120 years from the date of creation.

- Works published before 1923 are no longer covered by copyright, and neither are materials (including photographs) published without a copyright notice from 1923 to 1977.

- There are exceptions that are covered by copyright, such as works published without a copyright notice but later registered between 1978 and 1 March 1989. Sharon DeBartolo Carmack, in "Hard Copy"

(*Family Tree Magazine,* December 2004, pp. 38–41), advises "assuming that anything published in the last 75 years is protected under copyright law."

Rules to Follow

- Make sure you have permission from the owner to use a photograph on your website (websites are considered publications), and follow the copyright rules previously outlined.

- Photos published before 1923 are in the public domain and can be used without permission.

- Before you use any historical photographs, determine if they were ever published (i.e., made available for general distribution to the public) and when the photographer died.

- Suppose you purchase an original photograph at an antique store. It was never published, the photographer is dead, and it is unidentified. Can you use it? The rule of waiting seventy years from the death date applies in this instance.

- Photographs with a copyright notice or that appear in a book may need special permission to be copied. If in doubt, consult the copyright table on the Copyright Office website at <www.copyright.gov/title17>.

Permission vs. Copyright

Suppose you come across a family photograph in an archive or at a historical society. There are also ethical concerns with historical photographs found in museum collections. Since you probably won't want to use just a photocopy of this image, you'll want to approach the museum or archive about making a photographic copy. You'll have to pay a fee for this service and tell them how the picture will be used.

If you decide to publish your scrapbook or use the photograph online, you may have to pay a usage fee. Even though the museum may not be able to claim copyright to these photos and many are in the public domain, it can license you to use them and charge a fee for the usage. If the photograph is a unique item, you should pay the fee (it will vary from institution to institution); however, if the photograph was published prior to 1923 and unaltered copies are available in other institutions, then it is in the public domain.

Family Photographs Taken by Professional Photographers

Several professional organizations, including the Professional Photographers of America, have agreed to adhere to a set of copyright guidelines outlined by the Photo Marketing Association International. A complete set of the responsibilities of the consumer and

professional photographers is on the Kodak website at <www.kodak.com/global/en/consumer/doingMore/copyright.shtml> or in the *ASMP Guide to Professional Practices in Photography*.

If you want to use a family photograph taken by a professional photographer, apply the following criteria:

- Photographers hold the copyright for photos; therefore, you cannot publish any professional studio photographs of relatives without the photographer's permission *and* your relative's okay.

- The reverse is also true. In order for professional photographers to use your photo in advertising or publications, they also need a release from you beforehand. Copies of releases and an explanation of rights appear in the *ASMP Guide to Professional Practices in Photography*.

Obtaining Permission

- If you want to use a photograph taken or published after 1978, obtaining permission can be a simple procedure as long as you can contact the current copyright holder. Locate the photographer by using telephone directories (phone and online), by typing the name into an online search engine, or through a membership directory such as the American Society of Picture Professionals <www.sitewelder.com>.

- Send the photographer a letter or e-mail requesting permission and outlining how the photograph will be used. In many cases, you will have to pay a royalty (usage fee) for the right to publish the photo.

- Obtain written permission from both the photographer and your relative in case a legal issue arises.

- Contact the copyright holder, such as a newspaper, book publisher, or website owner, for published material. If the website lacks an e-mail contact, search the domain name in a domain registration site and write to the address listed. In the case of photographs that appear in newspapers or magazines, the photographer may own the copyright instead of the publication, but the publication's authors or editors should be able to provide you with the photographer's contact information.

Copyright Your Photographs?

Whether you should register the copyright for your family photographs is a personal decision. If you intend to post them online or publish them in some format, a copyright notice can warn others that they should not duplicate your photos without permission. Unfortunately, it doesn't always work. Copyright violations are growing with the ease of cut-and-paste functions. Here's what you need to know:

- Copyright is now automatic. It doesn't require you to put a copyright notice, date, or name on an item. However, officially registering a copyright is a good idea if you intend to sell your photographs.

- Copyright forms are available at the Copyright Office website at <www.copyright.gov>. All you have to do is download the forms, fill them out, and pay a fee ($30 covers registration for a group of images).

- When you publish your pictures, include the copyright statement (name, date, and symbol) to remind people not to misuse your photographs.

- Peter Marshall, in his article "How to Copyright Photos" on About.com, suggests adding a digital watermark to your photos. This creates "an invisible marker in the picture" with your copyright data.

- Remember that copyright lasts for seventy years after the death of the creator, not seventy years after registration or publication.

Photo etiquette is about using your common sense. If an archive says it doesn't allow cameras, accept the rules and inquire about other ways to obtain the photos

Standards for Sharing Information with Others

Recommended by the National Genealogical Society

Conscious of the fact that sharing information or data with others, whether through speech, documents, or electronic media, is essential to family history research and that it needs continuing support and encouragement, responsible family historians consistently—

- respect the restrictions on sharing information that arise from the rights of another as an author, originator, or compiler; as a living private person; or as a party to a mutual agreement.

- observe meticulously the legal rights of copyright owners, copying or distributing any part of their works only with their permission, or to the limited extent specifically allowed under the law's "fair use" exceptions.

- identify the sources for all ideas, information, and data from others, and the form in which they were received, recognizing that the unattributed use of another's intellectual work is plagiarism.

-

- respect the authorship rights of senders of letters, electronic mail, and data files, forwarding or disseminating them further only with the sender's permission.

- inform people who provide information about their families as to the ways it may be used, observing any conditions they impose and respecting any reservations they may express regarding the use of particular items.

- require some evidence of consent before assuming that living people are agreeable to further sharing of information about themselves.

- convey personal identifying information about living people—like age, home address, occupation, or activities—only in ways that those concerned have expressly agreed to.

- recognize that legal rights of privacy may limit the extent to which information from publicly available sources may be further used, disseminated, or published.

- communicate no information to others that is known to be false, or without making reasonable efforts to determine its truth, particularly information that may be derogatory.

Ethical Considerations

- are sensitive to the hurt that revelations of criminal, immoral, bizarre, or irresponsible behavior may bring to family members.

©2000 by National Genealogical Society. Permission is granted to copy or publish this material, provided it is reproduced in its entirety, including this notice.

123

you need or want. There are usually alternative options if you ask.

There are many ways to link cameras and genealogy. This book has explored a variety of issues confronting family photographers, such as equipment choices and photographic techniques for still and video formats. It has also covered some of the specific ways that genealogists use photography to document their family, from photos of everyday life to using picture taking as a tool to capture documents and artifacts. As many family historians now know, photography is an essential part of genealogical research. So bring a camera with you on every research trip, and start exploring the possibilities—just remember to ask first and be polite. Those two habits will answer most ethical questions before they become eithical issues.

References

American Society of Media Photographers. *ASMP Professional Business Practices in Photography*, 5th edition. New York: Allworth Press, 1997.

Fishman, Stephen. *The Public Domain: How to Find and Use Copyright-Free Writings, Music, Art and More.* Berkeley, CA: Nolo Press, 2004.

Gendreau, Ysolde, Axel Nordemann, and Rainer Oesch. *Copyright and Photographs, An International Survey.* London: Aspen Publishers, 1999.

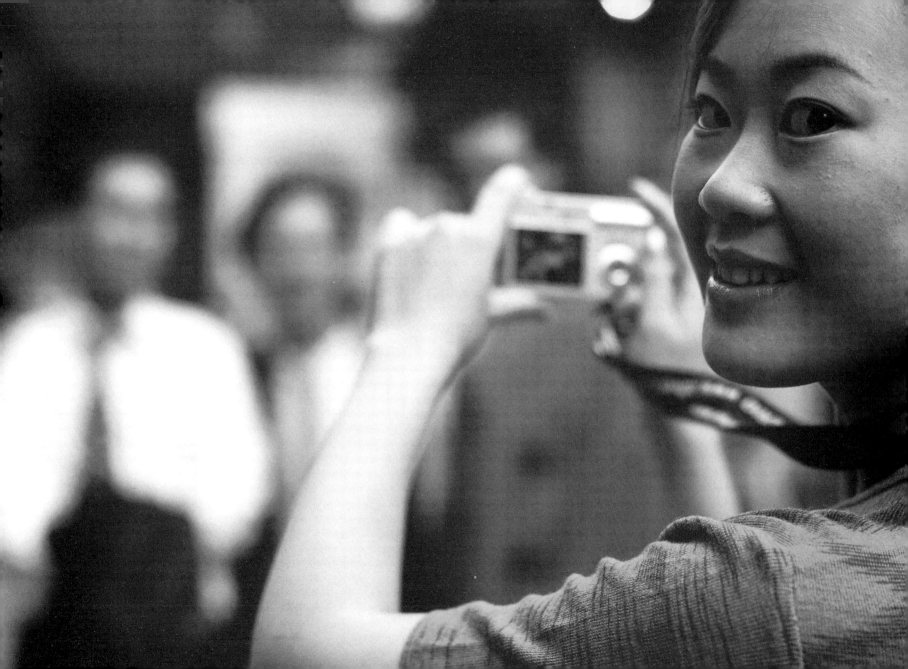

Digital Cameras

DIGITAL IMAGING OFFERS FAMILY historians and others an easy way to share, edit, and import photographs into websites and genealogy programs. If you don't already own a digital camera, you will soon. The largest growth in the photo industry has been in digital cameras. Over the last few years, sales of digital cameras increased as their cost decreased. Digital cameras are everywhere—from handheld devices to cell phones—and that's changing how and what we photograph. A friend confided that he rarely took pictures with his film camera, but now that he has a digital camera, he can't stop taking them. He bought a large-capacity memory card and a lightweight, compact digital camera that he carries everywhere.

There is a lot to love about digital cameras. They are convenient, easy to use, and have lots of features. Most models come with an LCD screen, letting you preview what you're going to photograph. It just takes a few minutes to adjust to looking at the back of the camera rather than through the viewer, but after that it's easy. It's instant gratification for any photographer who's worried about getting the shot right. Don't worry. With a digital camera you can always snap another and another until you take the perfect shot.

Once you've tried a digital camera, you probably won't go back to film.

Digital imaging is a fairly new technology. In 1981, Japan introduced the first camera with electronic images. At tens of thousands of dollars each, they were too expensive for the average photographer. The cameras also weighed around eleven pounds because of the external hard drive the user carried in a shoulder harness. Sony issued the ProMavica MVC-5000 in 1989, and it stored photographs on a floppy disk. By 1991, only a few professional photographers had access to electronic cameras.

Now, of course, you can purchase a digital camera for less than $100, and they resemble traditional film cameras in lens quality and weight, as well as photo quality. You can even purchase single-use digital cameras. There are a few differences between shooting film and digital, and it's not just the size of the camera. First, you need to learn a new vocabulary to sort out the pixels from the JPEGs. Printing is another dilemma for many consumers. Do you use a professional lab to produce prints or your home printer to do it yourself?

Digital cameras have several advantages. Take the camera with you to a relative's house to make copies of family photographs; visit the cemetery and, voila, you have photographs of the headstones that you can download to your computer and use that day. Going to a family reunion? Bring the camera with you and e-mail copies of photos to relatives without any extra cost.

A Few Helpful Terms

- Noise: Fuzzy pixels produced in low-light situations.

- TIFF: A picture format that gives maximum file size and picture clarity. This is the file format to choose for preservation reasons because it is uncompressed.

- JPEG: A picture format through which images are compressed to save file space. You can store more JPEGs than TIFFs on a memory device, but a little image quality is lost with the compression.

- DPI: Dots per inch. A printing term used to describe the number of pixels in an image for a given print size, such as 300 dpi, which is considered the standard traditional print resolution.

- Pixel: The smallest picture element that relates to picture clarity. The horizontal number multiplied by

the vertical number results in the number of pixels. An image with 1800 x 1200 pixels will produce a 6 x 4-inch print at 300 dpi. In general, the higher the number of pixels, the sharper the picture you'll see.

- Resolution: Picture clarity and sharpness based on image format.

- Shutter lag: Refers to the delay between the photographer pushing the button and the shutter opening. Reviewers often remark on the "lag" in digital cameras.

Advantages

Preview

An extremely useful feature of digital cameras is the ability to "see" what you are shooting through the monitor at the back of the camera. You can use it to frame your photograph prior to snapping the shot or to check your work later by playing back your photos.

Variable Format

Choose the look of your photo. Depending on the model, you might be able to shoot black-and-white,

color, or sepia. Instead of taking a whole roll of one kind of photograph, you can vary the format from image to image. An alternative is to wait until the editing stage to manipulate the look of your photos.

In-camera Editing

Most models offer the option of editing shots while they are in the camera. Delete unwanted pictures immediately instead of downloading them, or create a panorama of similar shots.

Storage

The largest roll of film on the market contains only thirty-six frames, but it's possible to store more than one hundred photographs on a single memory card. The number of photos you can place on a memory device depends on the resolution of the photos and the storage capacity of the device.

Free Factor

This is a debatable advantage. You won't incur the costs of film, but if you use a camera that takes AA batteries, you won't notice the "free" factor. You'll be spending money replacing the batteries. Invest in a set of

rechargeable batteries, or buy a camera with a different power supply.

Disadvantages

No Negatives

Digital photography creates an electronic file but no negatives. Maybe you don't need them. Create a backup of your picture files using a CD, DVD, or external hard drive.

Once Deleted, Gone Forever

Almost everyone has a digital tale of accidentally deleting pictures from the camera. Instead of deleting photos directly from the memory device, it's good practice to download them first, especially if you're unfamiliar with the controls. Another *possible* solution to this disadvantage is to invest in data-recovery software such as *Image Rescue* <www.lexar.com/software/image_rescue.html> or *PhotoRescue* <www.datarescue.com/photorescue>. Data-recovery software can usually restore deleted image files from a digital camera's memory card, as long as you have *not* already recorded new images over the previously deleted files.

Power Supply

Part of your camera selection will include choosing a camera that uses rechargeable NiMH (nickel-metal hydride) batteries, AA batteries, or Li-ion (lithium ion) batteries. Lithium batteries are more expensive than other models, but they are high powered. Neither NiMH nor Li-ion batteries use poisonous metals. Buy high-quality rechargeables compatible with your camera. Save yourself from running out of power on vacation by buying an extra battery pack and charging it before you leave for a trip. AA batteries are easy to locate, but you can use up a lot of them in a single afternoon. Use your set of rechargeable ones, keeping regular batteries in your camera case as a backup.

Storage

You can't just pop in another roll of film if you run out of space on your memory device. If you take a lot of pictures, invest in an extra memory card so you don't run out of room on a family history trip.

Preservation

This is a big problem. Saving digital images on your computer or on a series of CDs works as a backup medium as long as your machine doesn't malfunction and the CDs are stored at a stable temperature and humidity. There are ways to cope with this issue, and they are outlined later in this chapter.

Purchasing Criteria

Before rushing out to buy a digital camera at a great sale price, stop and think about how you'll use it, following the advice in the chapter "A Camera for Everyone." There are several key factors that influence affordability. You'll want to examine that "great buy" in terms of its features.

Megapixels

The key word in this technology is megapixels. It's a general term that refers to photo clarity and sharpness. The higher the resolution, the sharper the photograph and the larger the print you can make. Images on the Web are generally 72 dpi/ppi (dots per inch or pixels per inch). This data is usually advertised on the front of the camera as a number of megapixels, with current consumer cameras ranging from one to twelve megapixels. The number of megapixels has been increasing for several years, but how much is really necessary?

a camera that has complex controls and elaborate instructions unless you're comfortable with that level of technical information.

Power Supply

This is more than a discussion of advantages and disadvantages. Some people like using a NiCad (nickel-cadium) battery pack, while others want the flexibility of being able to purchase batteries whenever they need them. Think about this decision carefully. In any case, rechargeable units are available, as well as extra packs. If you travel outside the country, ask store personnel if they know how to charge the power supply when on the road.

Lenses

Usually cameras come with either a digital or optical zoom. An optical zoom resembles a film camera's telephoto lens, while a digital zoom increases the number of pixels in the center of a photo, creating fuzzier close-ups. Canon makes an SLR digital camera that can use lenses from one of its popular film models. This makes sense if you own a lot of lenses and want to reuse them.

Peripherals

When purchasing a camera, ask what peripherals you'll need. If you own a digital camera, you know it means at least having a computer, printer, and other peripherals, including software.

Here are some questions to ask:

- Does the camera connect directly to your computer via a USB cable for downloading, or do you need a separate memory card reader? Most new computers come with slots for downloading directly from a variety of memory devices. There are some stand-alone photo printers on the market that don't require a computer, but you have no way to save your digital files. Kodak's Easy Share Camera wirelessly downloads photographs to your computer.

- Does it come with the USB cable, or does that need to be purchased separately?

- Is your computer going to be able to handle large numbers of picture files?

You can start out with an inexpensive camera, but with all the extras, you'll be surprised how fast the costs add up. In addition to the camera, you might discover

you need a new computer to handle the files and a printer to make copies. So make sure you understand your camera needs before you make that purchase and add up the final charges.

Making a Decision

The first thing I do is ask my friends about their cameras. I want to know what they like and dislike about them. They offer comments about using the cameras in real-life conditions. My next step is to consult online reviews. A good camera retailer will let you try several models in the store and can provide some insight into what you're considering. Here are a couple of websites to help you evaluate the options.

Steve's DigiCams ‹www.steves-digicams.com›

Keep up on the latest in digital imaging—cameras and peripherals. The site has links to manufacturers and a digicam dictionary of terminology for the novice.

PC Photo Review ‹www.pcphotoreview.com›

See what's new in cameras and accessories, find an online sale, or join a discussion group. This site has lots to offer.

Digital Photography Review ‹www.dpreview.com›

This site has camera reviews, discussion forums, and a gallery of digital pictures. A buyers' guide and side-by-side comparison of features helps consumers make an informed decision. Search the site for industry news or feedback in the forums.

Unsure of what to buy? Consult an online reviewer for more information.

135

Megapixel.net ‹www.megapixel.net›

This site is a monthly online webzine that features articles, classifieds, and reviews in either English or French. The articles cover photography tips, peripherals, and cameras.

Purchasing Options

Today's marketplace offers an educated consumer a number of choices, including previously owned models and shipping to your door. How you purchase a camera and peripherals is a personal decision, but having the facts helps you make an informed selection.

Used vs. New

There is nothing wrong with purchasing a used digital camera. You won't end up with the latest model, but the savings could be considerable. Make sure it's compatible with your other equipment and is in good condition. Some stores sell used equipment with warranties, so inquire about guarantees. Photographic membership organizations like the Photographic Historical Society of New England sponsor events with vendors selling previously owned equipment.

Online vs. Store

The Web is a great way to comparison shop. Many shopping sites let you select models and then compare their features. Large shopping sites like Yahoo.com list vendors and prices for the same item along with customer ratings for vendors. Before purchasing online, check to see if the connection is secure for credit card transactions (use a card insured against fraud) and ask about shipping. While a site claims to have quick shipping, you won't receive your order in the promised number of days if the item is not in stock.

Purchasing cameras in person through a retail store has the added advantage of allowing you to try out the equipment. A salesperson will be handy to answer questions, and you'll be able to buy on-site.

Basic Rules of Usage

Your grade school teacher probably advised you to read the directions before taking any test. Using a digital still camera requires that you read the manual that comes with it. If you don't, you might press a button and accidentally delete all your photos, like one user did. While manufacturers aim to make their cameras user friendly, digital cameras are complicated, and reading

the manual will help you understand how to make your camera work for you.

There are lots of dos and don'ts about handling your digital camera. For instance, don't take it to the beach or expose it to water (unless it has been made for that purpose) because the internal workings could be damaged. Do have fun with your camera, viewing the pictures as you take them and editing them later. If you need help understanding how to care for your camera, try the camera manufacturer's website, or consult one of the many guides on the market.

All cameras should be treated with care to extend their longevity, but it's important to ask sales staff about any special usage conditions. Camera specifications usually include information on temperature ranges that won't damage the device. Early-model digital cameras were extremely fragile and susceptible to damage when used outdoors. Newer models are more resistant. The HP Digital Photography Center recommends creating a "raincoat" for your camera by using a plastic bag with a hole cut for the lens to protect it from water. In general, avoid heat (don't leave it in the sun in your car) and immersion in water (unless it is an underwater model). Sand can damage lenses as well as memory devices and

can affect functionality, so don't place your camera on the beach. Keep it in the camera case when not in use. Problems like dropping your camera on a hard surface are inadvertent mistakes, and you might have to replace your camera rather than fix it. Regular maintenance, such as cleaning your camera and lenses using a clean, soft cloth and using a lens cap to protect the surface of the lens, will extend the life of your camera.

Shooting and Saving Photos

Here's a common question: Should I shoot JPEGs (low resolution) or TIFFs (high resolution)? A simple answer: TIFFs are considered a preservation-quality format because of the high resolution. Once you've shot a JPEG, it isn't possible to change the resolution into a high-resolution TIFF file. If you own a camera that allows you to shoot TIFF files and you have a large memory card, then TIFFs are a good choice.

As you start downloading those cute photographs of Susie's birthday party or Aunt Mabel's gymnastics at the last family reunion, keep in mind that these photos are computer files. That means you have to periodically back them up the same way you do your data files. If you consistently back up your picture and data files,

congratulate yourself. If not, try to do it regularly to prevent photo losses due to computer failures. Make two copies of the backup—one for using and the other for your archives. Store them in two separate places,

protecting them from floods, heat, scratches, and operator mistakes. If you click the wrong button, you might inadvertently erase the disk or drive on which you store your photos. There are a few choices:

- *CDs*: While CDs used to have a short shelf life (under ten years), manufacturers now claim the disks last at least fifty years. Store your CDs in the same environment as your original photographs—at a temperature of no more than 77 degrees Fahrenheit and 40 percent humidity. Label CDs/DVDs with a special soft tipped marking pen that prevents data loss.

- *DVDs*: DVDs have seven times the storage capacity of CDs and can be viewed using a TV and DVD player. Store them the same way you do your CDs.

- *External hard drives*: Relatively inexpensive, they come in different capacities and will back up all your files at once.

- *Media players*: Load your photos onto a media player. You can insert the memory device into a media reader for the iPod with a dock connector like the one made by Belkin <www.belkin.com>. Or plug your camera USB cable into Apple's Digital Camera Link for iPod with Dock Connector and download directly from the camera.

- *Memory stick or Flash drive*: Portable, compact, and handy, these devices use your computer's USB port.

There is one to fit every budget, and you can carry it on your key chain.

Reading the Specifications: Digital Cameras

Buying a digital camera is a bit overwhelming at first, even if you're an experienced film camera user, because of variations in features and terminology. Here are a few features you'll find in the specifications and what they mean. And if you find another term you don't understand, try entering it into Webopedia.com <www.webopedia.com>, a glossary of technical terms.

- *Aperture:* An adjustable opening in the camera that controls the amount of light passing through the lens. This is marked by f-stop numbers on the aperture ring, usually given in minimum and maximum f-stop numbers that refer to the depth of field of the photo, i.e., how much of the scene is in focus.

- *Connectors:* Refers to how your camera connects to a computer. There are several types:

 - Universal Serial Bus (USB)—Yahoo! Shopping defines this as a "faster connection than standard serial ports" that allows you to connect more than one device to your computer without restarting the machine.

 - Serial port—The term *serial port* is usually applied to either the DB-9 (nine pin) or the DB-25 (twenty-five pin) ports built into most computers. These ports allow you to connect low-speed peripherals, such as printers or mice.

 - IEEE 1394—In camera specs, it might be called a firewire or i.Link. It is especially good for downloading multimedia files at fast speeds, and like the USB, you can connect and disconnect more than one device without rebooting.

- *Focal length:* References the field of view. The smaller the number, the wider the angle of view.

- *Focusing range:* Maximum and minimum ranges of focusing capabilities.

- *Image format:* Lists the types of picture files created by the camera, such as JPEG and TIFF.

- *ISO settings:* While you aren't using film, digital cameras still offer speed for variable light settings similar to those available for film, such as 200, 400, and 800.

- *LCD screen size:* Measurements of the liquid crystal display on the back of the camera.

- *Metering characteristics:* How the camera's light meter determines the light level.

- *Operating temperature:* Maximum and minimum temperatures at which the camera will operate without damage.

- *Shooting modes:* In addition to still photographs of a standard size, a camera may be able to shoot panoramas or movies.

- *Shutter speed:* The speed of the shutter opening and closing during a shot. This is important for freezing the motion in an action shot.

- *White balance:* Measures and adjusts light levels so you don't end up with the yellow or bluish color cast prevalent with different types of lights. Some cameras come with controls that allow the user to select a white balance, such as cloudy, sunlight, fluorescent, or incandescent, while others correct the lighting automatically.

It is no surprise that genealogists are turning to digital photography to save their family memories. Digital cameras offer professional-quality imaging options from cameras that are simple to operate. Digital imaging is quick, convenient, and easily shared. You'll be able to think of creative ways to use your camera to document your family tree. Take pictures of family artifacts, use it to copy heritage photos in relatives' collections, make creative name tags with imaging software for the next family reunion, or simply take pictures of family members. It really doesn't matter how you use the camera as long as you find time to preserve your family's visual history.

References

Freeman, Michael. *The Complete Guide to Digital Photography.* Rochester, NY: Silver Pixel Press, 2001.

Long, Ben. *Complete Digital Photography.* Hingham, MA: Charles River Media, 2001.

RootsWorks <www.rootsworks.com>. Features a series of articles on technology for genealogists written by Beau Sharborough.

Film Cameras

IN THE BUZZ ABOUT THE LATEST digital photography news, it's easy to overlook film cameras. At this point, digital hasn't completely replaced film as a photographic method, but if you believe what's written in popular magazines, then it's only a matter of time before film is obsolete. Yet there remains a wide variety of film camera choices for consumers—point-and-shoot compacts, single-use cameras, instant photographic models, and the once professional single-lens reflex (SLR). Recently, Canon and Nikon announced they would stop producing film SLRs, making the future of film photography uncertain.

A lot has changed since Kodak issued the first amateur cameras in the late 1880s. They began as simple point-and-shoot models. Amateurs didn't struggle with film, fancy lenses, or even reloading the camera. Each unit arrived fully preloaded with film. When you were done taking pictures, you sent the whole camera back to the factory for film processing, prints, and reloading. Today cameras come in all shapes and sizes and use different-sized film and lenses.

Variety, Variety, Variety

The photographic marketplace is changing so rapidly it is difficult and expensive to keep current. Maybe you

don't have to. All you need to document your family history is a good camera with a nice lens and whatever features you require. Many individuals are using cameras that are more than ten years old. Updating your equipment is a requirement when your needs change but may not be necessary as long as your camera is in good working condition. However, there are reasons to consider buying a new camera. Current models offer a wide range of sophisticated options at an affordable

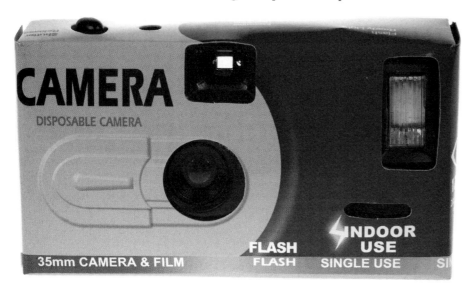

price. Features that were once out of financial reach of the average consumer are now standard on less expensive models. If you've considered updating your equipment, the abundance of choices and affordability makes this an opportune time to explore what's available.

Single-Use Cameras

Single-use cameras have been available since the late 1980s, and sales of these cameras continue to be steady. I began purchasing single-use cameras for my children when they were toddlers. They were excited about having the responsibility of their own cameras and would insist that family members look at their vacation photos. As you might expect, there were plenty of throwaways, but in every roll there were a few keepers. Now that they're older, they look at their photographs critically and try to take better shots with each roll. They also ask for cameras to document their everyday lives in addition to vacations. The cameras are fairly inexpensive, but by watching for sales and special offers, I can save even more and keep a few on hand for spontaneous occasions. My kids like to photograph friends, teachers, and the moments that mark their lives—especially the last day of school. These cameras help train my children

to think about what moments in their lives are worth preserving.

Advantages vs. Disadvantages

Cost

This is probably the number one reason individuals select single-use cameras. They are much less expensive than purchasing a camera that requires reloading. Look at store circulars for special offers and coupons to maximize your savings. Costs vary based on the manufacturer, format, and number of exposures (usually fifteen to thirty-six). If you forget your camera at home and need one in a rush, it's possible to purchase them everywhere from grocery stores to camera outlets. There are even single-use digital models.

Flexibility

Single-use cameras come in a variety of formats. It's possible to take panoramic or underwater pictures without investing in special equipment. Models with built-in flash units make it possible to take pictures in a variety of settings.

Ease

If my toddlers could use them, anyone can. There are no special controls or focusing required. You just point and shoot. Drop a couple in your suitcase or tuck one into your purse, and carry them with you wherever you go. Wind the camera to the number one position and start taking pictures. Remember to forward the frame after every shot, or you'll end up with an abstract print of several images merged into one.

Durability

I can't imagine taking my digital camera or my SLR to the beach because there is too much sand, salt, and spray. Single-use cameras are a perfect solution for outdoor activities. Put a couple in your photo kit for impulsive picture-taking moments. My son recently dismantled one of these cameras to see how they worked *after* he'd taken a roll of film. Thankfully, the hard plastic inner workings protected the film from light exposure so I could still have it developed. Unless the camera is an underwater model, keep the cardboard box away from water. The outside casing will disintegrate, possibly exposing the film to light and moisture and ruining your photographs.

Shooting Tips for Single-use Cameras

- Stay at least four feet away from your subject.
- Don't expect to be able to take closeups.
- Keep the camera dry, unless it is an underwater model.

Photo Quality

Single-use cameras take adequate pictures. They lack the lens quality found on more expensive film and digital cameras, so the images are not as sharp. The key to using them is knowing their limitations. On some models users need to remember to turn on the flash unit because it is not automatic. These are not the cameras to use if you're trying to take closeups of documents or copies of older photographs. If you're trying to take pictures in a darkened room, it's best to stand within a few feet of the person you're photographing. The flash is only useful for limited distances.

Recyclable Parts

Photo finishers send the camera and its parts back to the original manufacturer once they've removed the film for processing.

Instant Cameras

Edwin Land pioneered instant photography in 1947 when he patented a process for taking black-and-white pictures that developed in a minute. For the first time since the beginning of photography, family photographers could shoot a picture and see the results within seconds. Polaroid Corporation offers many different models to appeal to amateurs, professionals, kids, and teens. Its website, <www.Polaroid.com>, features a camera comparison tool that lets you select three current models and compare their attributes. Polaroid makes instant cameras with built-in flash and professional-quality models with both digital and optical viewfinders. While this section covers only Polaroid's film cameras, the company now offers consumers a line of digital cameras as well.

Advantages vs. Disadvantages

Cost

The camera costs are reasonable for most models; however, the average cost per photo is higher than any other

camera because of the price of film. Packages of film contain only ten to twelve frames, depending on the size of the film. The image area of each frame ranges from a square format approximately one inch to three inches to a rectangular image of varying sizes.

Easy to Operate

Consumer models allow users to point and shoot. More sophisticated models include additional lenses and the ability to focus before shooting. Film comes in an easy-to-load cartridge. Early models used roll film, but in the 1960s pack film required users to pull the photo out of the camera, time it for up to sixty seconds, and then peel it apart. In 1972 a different type of film known as integral film was introduced; it was used with the Polaroid SX70 folding camera and is now also found in the very popular Polaroid One Step. This film pops out of the camera, and you watch it develop.

Fun Factor

Low-cost, ultralight models marketed to teens and young adults take small pictures (approximately one-inch square). Some models also use sticker film for shooting frames with an adhesive back. Polaroid instant

film with an average three-inch image area also comes in novelty packs for parties and holidays. Decorative edging forms a frame around the photo themed to a particular event, such as Halloween.

Feeling artistic? Go to the Polaroid website and click on the "creative" link to explore ways to do image transfer, manipulate the image, and more. Look at online exhibits of professional artists who use Polaroid

Instant photography is attractive because you can take a picture and get a print within moments.

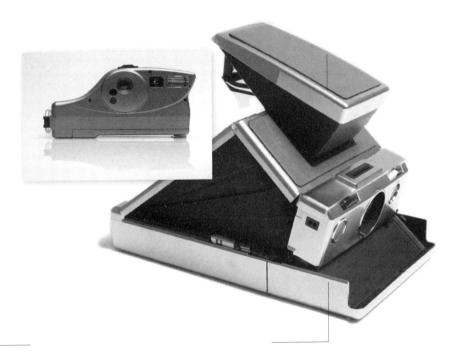

147

Tips for Instant Cameras

- Bring along extra film packs. It doesn't take long to take ten frames.

- Use film packs before the expiration date.

- Read the storage conditions for the film; it is sensitive to heat because of the chemicals in it.

- These cameras are not intended for landscape photography; plastic lenses and a flash work best for portraits.

- Don't cut the image unless you are going to try one of the creative art techniques mentioned on the website. Cutting a Polaroid photo destroys the picture and exposes you to chemicals. The photo consists of chemicals between plastic sheets. It is not an image printed on a piece of photo paper.

Tips for Compact Cameras

- Be aware of the flash range before taking a picture.

- Carefully frame your shot to account for the difference between lens and viewfinder.

- Point your camera at your subject to compensate for autofocus.

cameras and film. A craft section provides instructions on how to make invitations, frames, and photo books. Articles in each section explain how to create using Polaroid products and show examples.

Immediacy

Until the digital age, photographers had two choices: (1) wait for their film to be developed or (2) take instant shots with a Polaroid. The immediacy of holding a photograph and watching it develop within moments of taking it is fun and satisfies our curiosity about whether we "got the shot."

No Negatives

Each Polaroid picture is unique. There are no negatives to make extra prints. Years ago, consumers sent their Polaroids to the company to have copies made, but scanners and photo kiosks for duplicating photographs have made that obsolete.

Compact Cameras

At some point in their lives, most people own a point-and-shoot or compact camera with or without a zoom lens. There are many different models of these cameras

for sale in various price categories. The cost of these cameras depends on the number of features.

Advantages vs. Disadvantages

Focus

Compact cameras have either a fixed focus or an autofocus. A fixed focus means no focus adjustments are made. Autofocus automatically focuses the camera lens where you point it. You must point at the person or object you are trying to photograph with most autofocus cameras because the camera will focus on the item in the center of the frame. If you don't want to worry about focusing your camera, an easy-to-operate, point-and-shoot, compact camera would be of great advantage to you. Many photographers own a compact in addition to another camera.

Size

Compact cameras are small enough to be carried in a pocket or a small camera bag. Models with zoom lenses are a little larger but are generally just as portable. Their size and weight make them ideal for tucking in a purse, a jacket pocket, or a small carry-on suitcase.

Variety

Not all compacts are considered point-and-shoot models. Single-use cameras and models with limited features are considered compacts, while newer compact models come equipped with a multitude of features, including exposure and focusing control. With the exception of the APS (advanced photo system) models, which use film slightly smaller than 35 mm (24 mm), compact models use 35 mm film.

Flash

All compact models come with a limited-distance, built-in flash. The biggest source of disappointment to users of these models is the range of the flash. It illuminates objects close to the camera—approximately three to six feet. Auxiliary lighting is needed for longer distances. There are other problems associated with built-in flash units. They tend to cause shadows and, in low-light situations, create "red-eye." Newer-model cameras are equipped with units that flash several times to eliminate this problem.

Battery

All of these cameras, with the exception of single-use models, require battery power. Carry an extra set with

What you see through the viewfinder isn't always what appears in a picture shot with a point-and-shoot camera.

you at all times. The more you use the flash, the more often you'll need to change batteries. A set of rechargeable batteries is a good investment.

Parallax Error

What you see through the viewfinder is not exactly what you'll end up with in a photo. *Parallax error* is a

technical term that refers to the fact that viewfinders are actually removed from the lens, thus "seeing" a shot from a different viewpoint. This isn't a problem with distance photographs, but tightly framed shots often lose detail due to this variation. Knowing the limitations of your viewfinder versus a lens is essential to taking successful pictures with a compact camera. If you end up cutting off the head of your subjects in every photo, it's probably due to parallax error. Adjust your shot, leaving adequate space above the head in the viewfinder, to include the whole person, not just a body.

Price

There is a compact camera for every budget. Cost depends on the number of features. A less expensive camera equals fewer bells and whistles. Compare the purchase price of various compact models with some simple-to-operate SLR cameras before your final purchase.

Single-Lens Reflex (SLR) Cameras

SLR models offer photographers flexibility and additional features. They cost more than compact models, but you can't beat their adaptability. Start with a basic

model; add lenses as you need them, treat them well, and they'll last a lifetime. With these cameras you'll want to start with the manual to become familiar with all the features. Film SLRs shouldn't be confused with digital SLRs, which are similar in format but offer different features.

Advantages and Disadvantages

Flexibility vs. Adaptability

Owning an SLR means you'll be ready for any photographic situation. Basic models feature exposure and shutter control. Think carefully about how you're going to use the camera. You'll purchase the camera body and then accessorize it with at least one lens.

Gadgetry

You could spend thousands of dollars on a variety of tools to enhance the usability of your SLR. Most of us probably don't need more than a couple of lenses. Start with a basic 50 mm lens. If you're going to take pictures of artifacts or closeups of objects, add a set of closeup lenses to your initial purchase. Add pieces of equipment as you need them. Start with a camera body,

Advanced Photo System

Kodak pioneered the APS camera and targeted the average consumer photographer, who takes snapshots and rarely asks for prints larger than 4 x 6 inches. Canon, Fuji, Minolta, and Olympus, as well as Kodak, all sell APS models. There are distinct advantages and disadvantages to this system. Here are the key features, both good and bad:

- Drop-in film loading
- Three picture formats: panoramic, wide-angle group, classic (4 x 6)
- Mid-roll removal in case you want to change film
- Index print that displays all the pictures you took
- Records camera/exposure information in the film so the photofinisher can improve prints automatically
- Prints larger than 4 x 6 inches lose image quality
- Uses a different size film: 24 mm
- Negatives approximately 50 percent smaller than 35 mm negatives
- Standard print prices compare to prints of the same size from 35 mm film, but labs charge more for the other formats

lens, lens cover, and camera bag. Some manufacturers offer packages of the body and lens, but make sure the lens will work with your picture-taking needs.

Size

The dimensions and weight of these cameras depend on the construction of the camera body (full metal ones are heavier) and the size of the lens. Buy a storage bag with a comfortable strap to offset the weight of the camera and equipment.

Price

SLRs cost more than compact models. Sometimes they cost a lot more. Professional models sell for $1,000 and up, but consumer models cost a few hundred. Accessories add to the total price.

Reading the Specifications: Film Cameras

- *Date imprint:* Some cameras print the date the photograph was taken on the film or in the digital image.

- *Film advance:* Identifies whether film advances automatically or must be moved forward manually, as with single-use cameras.

- *ASA/ISO/DIN:* This number appears on the side of a box of film or on a box of photographic paper. It refers to the "film speed," or light sensitivity, of the product. The higher the number, the more sensitive the film. For instance, a roll of 200 ISO film is not as light sensitive as one rated at 800 ISO. Therefore, ISO 200 film is better for bright sunlight, while you would need to use a higher ISO for low-light situations. ISO stands for International Standards Organization and is the most commonly used film speed measurement in the world today. ASA stands for American Standard Association. DIN is the European standard. These three appear on most film.

- *Film speed range:* Describes the right types of ASA/ISO film that can be used in the device.

- *Shooting modes*: Different model cameras offer a variety of shooting modes, such as closeup (macro), panoramic (extremely wide-angle view), portrait (comparable to a 50 mm lens), night, and sports (fast shutter speed). Some cameras refer to these as scenic, people, or flowers and use icons to represent them.

Appendix: List of Album Suppliers

Examine product specifications to ensure they are
acid- and lignin-free and use polypropylene or Mylar.

Anna Griffin Inc.
(888) 817-8170
<www.annagriffin.com>
Offers a wide variety of albums.

Celine Countryman
Image Archives
(612) 455-2247
<www.celinecountryman.com>
Store and product information is online.

Frances Meyer Inc.
(800) 372-6237
<www.francesmeyer.com>
Albums, paper, and other scrapbook supplies.

Hallmark
<www.hallmark.com>
Use the website to find a store near you.

Hollinger Corporation
(800) 634-0491
<www.hollingercorp.com>
Products intended for use in museums and libraries.

K & Company
(800) 244-2083
<www.kandcompany.com>
A wide array of scrapbook-related products.

Light Impressions
(800) 828-6216
<www.lightimpressionsdirect.com>
All types of photo products, including labeling pens
and albums.

University Products
(800) 628-1912
<www.universityproducts.com>
Products intended for use in museums and libraries.

Index

Index

digital video (*continued*)
 time code, 105
 transfering old formats to, 110–13
Digital Video Essentials: Shoot, Transfer, Edit, Share, 102
Digital Video Pocket Guide, 102, 105
documentation, 75, 77
DPI, 129
Dreamweaver, 89–90
DVD Maker Plus, 109
DVDs, preserving, 112

E

editing, 18–19
 photographs, 55
 software, 55–59, 93, 104–7
Epinions.com, 55
ethics, 115
extended service plan (ESP), 12

F

family magazine, 93
family newsletter, 93
family photo archive, 34–36
family reunions, 91–92
Farber, Daniel and Jessie, 63–64
Farber Gravestone Collection (online), 64
film, 15–18, 64
 ASA/ISO, 16, 152
 developing, 4, 15–18
 preserving, 111
 storing, 111
 tungsten, 16

filters, 73
flashes, 11, 50–51
 AF illuminator, 11
 fill-in mode, 11
 red-eye reduction, 11, 51
focal length, 10
focus, incorrect, 49

G

generation, 48
glass, UV-filtered, 88
grain, 48
gravestones, 61–69
 cleaning, 66–67
 documenting, 67
 references, 69
groups, photographing, 52–53

H

heirlooms, 70
home movies, 95
 composition, 103–4
 editing, 104–6
 and family history, 108–10
 lighting, 102–3
 planning, 101–2
hot shoe, 100
How to Do Everything with Digital Video, 102
HP Digital Photography Center, 137

I

ISO settings, 132

Index

W

warranties, 12–13
WebShots.com, 86
websites
 creating, 89–91
 family, 89–91
 photo-sharing, 82–86
Wilhelm, Henry, 19–20, 88

Y

Your Guide to Cemetery Research, 69

Z

ZDNet.com, 55

Hours of research. Centuries of family history. Finally, an easy way to share your discoveries.

• Combine historical records, family photos, and facts in professionally designed templates.

• Customize your pages to express your own unique personality.

• Print your pages at home or purchase a beautiful hardcover book that your whole family will love.

give it a try for free at **www.ancestrypress.com**

Your family story could fill a book. *Now it can.*

ancestrypress